Table of Contents

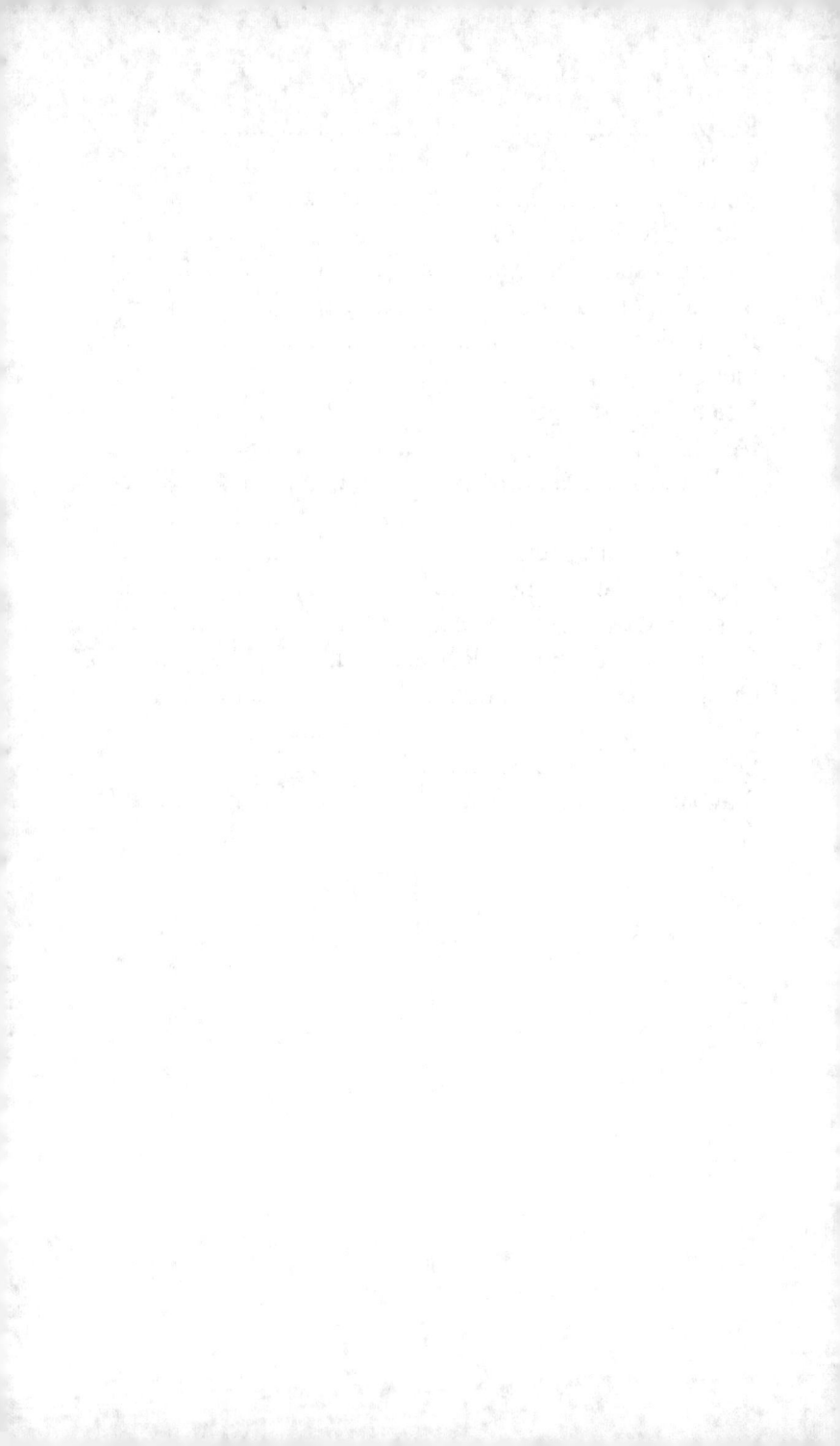

<u>Rec Menu</u>

<u>Motion Picture Menu</u>

Creative Video Menu

Custom Menu - Exposure

Custom Menu - Focus/ Release Shutter

Custom Menu - Operation

Custom Menu - Monitor / Display

Custom Menu - Lens/ Others

Setup Menu

My Menu

Playback Menu

6

iA Menu

My Example Menu

Focus Stacking Example

Multi Exposure Example
High Resolution Example
High Dynamic Range Example
Rolling Shutter or Jello effect Example

The Panasonic G9 Menu System Simplified

by David Thorpe

Published in the United Kingdom

First Publishing Date March 2018

Introduction

Panasonic's high end GH series cameras have long been regarded as video cameras that do stills. It was always a mindless cliché because the GHs were excellent stills cameras in their own right. Nonetheless, you will still hear photographers saying "Olympus for stills, Panasonic for video". The G9 will confound them. It is a stills camera through and through and designed to be so. That it still happens to do video better than most is just the icing on a very exciting cake. Like all high end Micro Four Thirds cameras, the G9 is a highly complex digital imaging machine at heart and for anyone new to the system or upgrading from a smart phone it can seem quite off-putting. It needn't be. If you want a simple life, just put the G9 in **iA** and it is no more difficult to use than your phone. On the other hand, you don't spend a large sum of money on a quality camera just to do selfies for Facebook and snapshots for Instagram. The G9 is capable of just about any type of work, from high speed sequencing to the kind high resolution more usually found in medium format cameras.

There's a lot to know about the Panasonic G9. **LVF Display Speed**? **AF-Point Scope Setting**? **ESHTR**? Some settings are crucial, some just good to know. This book doesn't try to teach you photography. Its aim is to familiarise you with the menu and settings of the G9, what they do and why you might want to use them. It is true that the camera is a tool but like

knowing your scales on a violin, mastery of the G9 will aid your aim of taking better pictures.

The menu system and controls of the G9 are well presented and logically laid out but with 6 sections containing around 180 main menu items, many of those with sub menus, even the most experienced user will sometimes find themselves scratching their head and wondering what an entry means. This small book goes through every menu choice and control and explains (a) what it does and (b) why you might want to do it. It may not inspire you in a literary sense but with its help you may find a G9 tailored to your personal taste inspiring to use. I sometimes give my opinion on the best setting. It is only my opinion from my personal experience. It is best treated it as merely a starting point for building your own experience.

At the end of the book I go though the menu items as I set them. The aim of this is to give you a working setup without having to learn what each item does straight away. As you use the camera with my settings you will find yourself thinking, "that's really annoying. If only I could change that." You most likely can. Find the item in question and change it. You now have a G9 a little more tailored to you than before. The aim, eventually, is to have a photographic tool that is personal to your needs. Actually, using the Custom settings and the ability to save and restore 10 further settings from an SD card gives 15 different G9s in one. If your interest is photographing the dim interiors of medieval churches using a tripod you might set your G9 to Aperture priority f8/ ISO 200/ AFS. You might

also like to photograph your son playing football with his school team using Shutter Priority 1/1000th/ ISO 3200/ AFC. Your stand camera and your action camera are but a click apart on the Mode Dial. A further click could take you to your favourite video setting. It is that flexibility and the sheer image quality of the G9 that makes it so exciting. The sheer configurability and operational versatility of the G9 can make it seem more the province of the rocket scientist than the artist. Time spent learning what the Panasonic G9 can do and how to do it will be rewarded by better results and ever widening photographic horizons.

If you find any errors or have comments to make, please email me at books@dthorpe.net

I have made a web page at books.dthorpe.net where I will list errors until I can correct them in the book itself.

The Controls

The majority of control over a complex, dedicated imaging computer, which is what the G9 really is, is

via the button. There are a few things so basic that they must be controlled by exterior levers and buttons. Those controls do not differ greatly from the ones which film camera users from the previous century would have been familiar. Set the camera to M on the mode dial and you can control shutter speed and

aperture directly. Press the ISO button and you have changed the 'film' speed. The rest of the external controls are essentially shortcuts to often used

menu items. Here is a brief rundown on the basics of

the body controls of the G9.

1. **LVF** (live View Finder) cycles between 3 selections, monitor on, eye level off/ monitor off, eye level on/ and auto switching between them. The obvious setting is auto but under some circumstances, when using a tripod and viewing on the monitor for example, your arm passing near the LVF sensor can cause it to switch to the eye level finder. If you are using the eye level finder and you take the camera from your eye to view the scene, the sensor will auto switch to the monitor. When you put

the camera to your eye again, you must wait a moment for the auto switch to take place. In that time, the bird may have flown! Switching explicitly to the eye level finder prevents that. In the **Custom** menu under **Eye Sensor** you have a a choice of **High** or **Low** sensitivity. **High** can be quite twitchy so **Low** is the general choice. Note that you can choose between monitor/ eye level/ auto in the **Eye Sensor** menu item too. If you find that convenient, you can free up the **LVF** which can then be used as **Function Button 3 (Fn3)**

2. The **Playback** button. After you have taken a picture, press this to review the image. You can, if you wish, review the image automatically by using the menu item **Auto Review** in the **Custom** menu.

3. The **Mode Dial**. This is the arguably most important control on the camera. The simplest setting is **iA**, Intelligent Auto. Set to this, the G9 becomes a point and shoot. You have limited control over how it takes the picture which makes it particularly irritating to experienced photographers like me because it is so often right! **P** is for Program where the camera chooses the shutter speed and aperture. **A** is for Aperture Priority. You set the aperture, the camera varies the shutter speed to suit your setting. Aperture is the deciding factor in how much depth of field you have in your picture. For a portrait, you would probably want any distracting background elements to be blurred,

in order to focus attention on your subject. For that you would limit your depth of field (obtain shallow depth of field) by using a wide aperture, that is opening your lens to its maximum f/3.5 or f/2.8, f/2 or f/1.4 if you have it. by Stop down to f/8 or lower and you have a wide depth of field so that you can get more of your picture in focus. If you are photographing a field of flowers, you can get flowers from near to far in focus. The downside to a small aperture is that to maintain the correct exposure, the shutter speed must be lower. This can lead to blurring of the image due to the camera moving during the exposure. Or, if there is anything moving in your picture, motion blurring. Which brings us to **S**, Shutter Priority. If you are photographing your children running around, they can move a surprisingly long way in, say 1/60th of a second. With **S** you can set a shutter speed fast enough to stop the motion blurring that a slow shutter speed would entail. The downside of a high shutter speed is that the lens aperture must be wider to bring in enough light for correct exposure. That, as I previously said, cuts your depth of field, making your focusing very critical, just what you don't want for a child's unpredictable movement. What the shutter speed gives, the aperture takes away and vice versa. As with politics, exposure is the art of compromise. **M** Manual leaves you to set both shutter speed and aperture. It can't achieve

anything that **A** or **S** don't but some people prefer to 'do it all'. Note that in all the previous, I have not mentioned the effect of the **ISO** setting. If you up the **ISO** setting you can have greater depth of field combined with higher shutter speeds. It looks like a win/ win situation. Unfortunately, as with everyday life, there are very few win/ win scenarios. As you raise the **ISO** setting, you are not increasing the amount of light , you are merely amplifying what you have. And as with a radio with a poor signal, the more you turn it up, the more background noise there is. On an imaging sensor, it manifests itself as a random 'rash' on your picture. This juggling act between shutter speed, aperture and ISO is at the heart of photography - only you can decide where your compromise will be. Note that a handy use of **M** is to set the shutter speed and aperture you want and then set the **ISO** to **Auto**. That means you can set the shutter speed to stop movement and the aperture to provide adequate depth of field. They will not change because the G9 will vary the **ISO** to keep the exposure correct. It can't brighten the ambient light, though, so ultimately, handy or not, it is one more compromise. The other settings on the **Mode Dial** are less specific. **Creative Video** gives you full control over your **Movie** settings, in contrast to the **Rec** button (14) which when pressed starts your video using the settings you have set as your default in the **Movie** menu.

The artist's palette icon gives you direct access to the **Filters** settings for various artistic effects. I describe the **Custom** settings in the body of the book. While there are only 3 **C** positions on the dial, **C3** can actually store 3 sets of settings on its own, C3-1, C3-2 and C3-3 chosen by pressing the **Menu/Set** button on the back of the camera after engaging **C**.

4. The **Drive Mode** dial. Not to be confused with the **Mode Dial (3)**. The **Mode Dial** sets the criteria for making the basic exposure. The **Drive Mode** dial sets the action of the shutter, whether it fires a single shot or a burst of shots for example. Set the dial in the

position for normal single shot shooting and the shutter will fire once using the **Mode** set. However, what if you want to bracket your exposures or use the self-timer? Using the Menus you can set the **Self Timer** to, say, 2 seconds and the **Burst Rate** to Medium. The **Drive Mode** is how you tell your

G9 to put them into action. Set to and the camera will shoot continuously at the speed

you have set. Set to it will shoot in **6K Photo** mode at 30fps using the method you

have preset in the menu. Set to it will engage **Post Focus** and the camera will take a series of pictures which you can view later and choose the focus point you wish. Particularly useful, the **Post Focus** images can be stacked to give you greater depth of field than would otherwise be possible. To do this, after the camera has finished taking and processing the Post Focus routine, press Fn1 or touch the icon on the top right of the monitor. You will be offered a choice of **Auto Merging** or **Range Merging**. Auto works well but if you prefer to choose, touch the areas you want in focus and then hit the **Menu/Set** button to merge the

areas you have chosen. Set to it will delay the shot for the time you have preset in

the menu. Set to it will use whatever **Time Lapse** or **Animation** settings you have made. So, if you want the camera to make a time lapse sequence, have set all the parameters you want and it doesn't do it - it's because you haven't told it to with the **Drive Mode** dial.

5. The **Flash** hot shoe. Remove the sliding cover and slide the flash into the hotshoe there.

19

If it is an Micro Four Thirds native flash it will automatically work as soon as it is turned on as long as **TTL** is turned on in the **Flash** menu. On the front of the G9 below the **Drive Mode** dial , there is another flash contact with a screw in plug. That is the flash synch socket and is used to trigger studio lighting or other external flash. It only triggers the flash and has no electronic connection to it so cannot operate any auto flash functions. Most photographers nowadays will trigger external flashes automatically via the hot shoe.

6. The **V.Mode** button. This allows you to set the EVF size. The maximum size is superb but for spectacle wearers like me makes the corners difficult to see and a bit blurred. For that reason I would prefer the smaller size which is, nonetheless, very big. However, this can work in conjunction with the **LVF/Monitor Disp. Set** in the **Custom** menu which allows you to view shooting information either superimposed on the image or on a strip underneath it. I prefer an uncluttered image area with the biggest display possible so set the **EVF** to its maximum size with the information displayed outside the image area. It is this kind of tailoring that makes the G9 such a joy to use.

7. The **Rear Dial**. This has different functions according to which **Mode**, **A**, **S** etc is chosen and is a key control during picture taking. If you are in **A** mode, for example, it

will change the aperture, in **S** mode the shutter speed. Some aspects of its operation can be tailored in **Dial Set.** in the **Custom** menu

8. The **Front Dial**. It has the same role in the control of the G9 as the **Rear Dial** and its functioning can be tailored in the same **Dial Set.** section of the **Custom** menu. My personal preference is to set the **Front Dial** to **Exposure Compensation** so that I can directly dial in any compensation without a button press.

9. The **Shutter Release** button. No need to emphasise the importance of this. Note that it too can be customized via several items in the **Custom** including setting it to release the shutter with a half press and locking focus and/or exposure.

10. The power On/Off switch. A further twist past the **On** position brings up a backlight for the **Status LCD**. You can set the brightness of the backlight in the **Setup** Menu.

11. The **White Balance** button. If you look at an object in daylight and then indoors by artificial light, the object will appear the same colour in both environments. Although the daylight contains much blue light and the artificial light much red, your brain instinctively compensates for the environmental differences. The camera cannot do this and must be told the colour temperature (more blue=colder, more red=warmer). You can set **WB** explicitly for sunlight, cloudy,

indoors and so on but in practice **Auto** is generally best. You can correct to some extent in post processing. **WB** is irrelevant when you are shooting **RAW** since it retains all the information from the image and can be set as you prefer afterwards. In the case of RAW, just set it to **Auto Note:** there are three types of Auto **WB**, simple **AWB** which is standard, **AWBc** which is for use under artificial light where **WB** may give too red (warm) a result and **AWBw** which retains the red enough to give a healthy looking skin colour. Since artificial light sources vary so much, the only way to ascertain which is best is by setting each and choosing the preferred one. Under most daylight conditions **AWB** copes very well.

12. The **ISO** button. **ISO** is the sensitivity of your camera's sensor to light. If the exposure at the light level in an indoor sports stadium yields an exposure of 125th@f/3.5 (full aperture) with ISO set to 200 with your kit lens, that will be fine for a static shot. For an action shot, you'll need a minimum of /500th to stop subject movement. You can't open the lens up any more to let in more light. What you can do is set the **ISO** to 800. That will give you your desired 1/500th@f/3.5. As ever with life there are no free lunches. To raise the sensor's sensitivity to light, it simply amplifies the signal. This amplifies any noise present too, which takes a grainy form of random coloured

dots. You have to decide for yourself how much noise you can tolerate in order to get the exposure settings you need. I happily use up to 3200 **ISO** without concern. You can reduce noise in post processing to some extent, at the cost of detail.

13. The **Exposure Compensation** button. The light metering system of the G9 is highly sophisticated and rarely wrong footed but it can happen. Sometimes, for pictorial reasons you want a lighter or darker result than the 'correct' exposure gives. In a snow scene, for example, the camera will tend to underexpose, rendering the snow grey rather than white. Good as it is, no auto exposure system is perfect. A press on this button brings up a +/- scale so that you can set the compensation that you judge necessary. I rarely find the exposure needs tweaking beyond + or - 2/3. One of the greatest assets of the **EVF** is that you can see live the effect of any compensation you make. If you want to hedge your bets, you'll see a panel in the top left of this compensation screen where you can set **Exposure Bracketing**. This will fire off 3 or more shots at different exposures automatically. Ultimately, although we think in terms of correct and incorrect exposure, the lightness or darkness of an image is an artistic choice

14. The **Rec** button. Press this at any time and the camera will start shooting a video using the default settings you have made in the

Motion Picture menu. To gain full access to video parameters you must set the **Mode Dial** to **Creative Video**.

15. The **Wi-Fi** operation light. This shows blue if you have **Bluetooth** or **Wi-Fi** on. If it is doing anything actively it flashes. You can disable it in the **Setup** menu, useful if you are using **Bluetooth** to write GPS location information to your pictures as you shoot and find it distracting.

16. The focal plane marking. This tells you where the sensor plane is. If you have a lens with a minimum focus of 20cm, it means 20cm from this point.

17. The **LCD Status** panel. This gives an immediate view of all the things you need to know about the G9 during shooting. White Balance, Metering Mode, Aperture, ISO, Shutter speed, card slots in use, battery status including battery grip if in use, exposure compensation, quality and picture size. Plus how many shots you have left at the current setting or time for video. This is a first for Panasonic and something you swiftly find invaluable. It can also mean you can turn the monitor off, a substantial battery saving.

18. The **Focus Mode** lever. **AFS/AFF** are single focus. When you half press the shutter button, the camera focuses and does not focus again until you again half press the shutter button. Whether the lever engages **AFS** or

AFF mode is set in the **REC** menu under **AFS/AFF**. I go into detail about the two modes there. **AFC** is continuous autofocus. All the time you keep the shutter button half pressed the camera will attempt to keep the subject in focus. If the subject is moving fast, the G9 will predict where the subject will be when the shutter fires. **MF** is manual focus where you turn the lens focus ring and judge sharp focus for yourself. This is of use on the rare occasions the G9 cannot find focus for itself. Generally speaking, the camera's auto focus will be faster and more accurate than your eyes. **Note:** I have outlined the use of the lever in principle. When you are set to any automatic **Focus Mode** you can customize many aspects of how it functions as you will see when you go through the **Rec** and **Custom** menus. This includes **Face Recognition**, **Tracking** and all sorts of goodies. It can be confusing but at root, the **Focus Mode** lever sets the overall

type of focusing, while pressing or the control on the **Disp.Info** screen (icon 2nd from bottom, 3rd from left) sets the way in which that **Auto Focus** will operate. I will go into more detail on the **AF Mode**s under the rear panel section further down this page.

19. This is the **AF/AE Lock** button. It can bet set to lock auto-focus, exposure or both. It can also bet set so the G9 only focuses when it

is pushed, giving you instant control over focusing.

20. The **Joystick**. This is a first for Micro Four Thirds cameras and puts the positioning of the **AF Area** under instant and intuitive control. Nudge it and the **AF Area** moves smoothly to any extreme of the frame. A half touch on the shutter button will set its position to wherever you have moved it. A press on the **Joystick** will move the **AF Area** back to dead centre. Another press will return to the previously set position. Not only that but while the **AF Area** is highlighted, turning the **Rear Dial** will alter its size. In conjunction with the **AF Mode**s the G9 offers unparalleled control over focusing. You can reassign it as a function button, for menu operation or even disable it if you wish. I don't think you will, though!

21. The viewfinder dioptre adjustment wheel (hidden from view). Set it for maximum sharpness when looking at the viewfinder information or a detailed scene.

22. The Viewfinder/ Monitor switching sensor. Sitting below the eyepiece, when it is blocked by your face the EVF operates, when you take your face away it switches to the monitor. You can set EVF or Monitor explicitly in the menu or via Fn5 by default.

1. Although this is **Fn1** and can be assigned as you wish, it also provides the only hardware way to access the **AF Mode** settings.

(The only other way is via the recording info screen). The **AF Mode** setting is crucial to getting the best focusing performance from the G9. I run through **AF Modes** at the end of this chapter.

2. The **Control Dial**. This is a versatile control which when turned will scroll though whatever parameter you are accessing on screen. Push the **ISO** button and this dial will run through the settings. It often duplicates another control such the **Rear Dial** which means that you can re-assign the **Rear Dial** to something else if you wish.

3. The **Menu/Set** button. It is basic to the operation of the G9, accesses the menu, sets and confirms the menu options and is used throughout the camera's operation for setting and confirming actions.

4. The **Cursor Keys**. Press the **Control Dial** where indicated and the dial acts like the arrow or cursor keys on other models.

5. The **Fn2** button is set to delete images in **Playback** mode and to step back through or out of settings in **Rec** mode. It acts rather like the Esc key on a computer keyboard. You can reassign

it, of course but the default settings are practical.

6. The **Disp.** button. This cycles through four EVF screen views varying from minimal information to comprehensive information, with and without the **Level Gauge** showing. For the Monitor only it cycles through an extra stage of **Monitor Off** which can save power if you are using the EVF exclusively. There is another option which applies to the monitor only which is **Monitor Info.Disp.** in the **Custom** menu. If this is set on, another screen is included in the **Disp.** button cycle, a recording information screen. This shows on one screen all the parameters you would normally want to change when out taking pictures or making a video. If you have **Touch Screen** enabled all the parameters displayed on the recording info screen can be accessed directly on touching. A useful item is the **Fn** with spanner icon. Touch this and a guide to all of your **Fn** Button settings comes up. Useful because they are easily forgotten.

AF Modes

- **Face/Eye/Body/Animal Detect.** will recognise a human face and set focus on the eye nearest the camera. Ideal for portraiture,It effectively removes the need for

you to worry about focusing at all, leaving you free to concentrate on your subject. There is also a box to switch **Animal detect** on. The G9, using Artifical Intelligence algorithms, will then search the frame for animals like dogs, cats and birds. Once locked on to the camera will hang on to the subject, keeping it in focus even if it turns away. A great boon for wild life or even pet photography. If there are several animals (or faces) in the frame you can select the one to track by lining up and pressing the Joystick

• **Tracking** will attempt to follow whatever you set it to follow and keep focus on it. It works remarkably well. Just touch whatever you want to keep in focus on the screen and the G9 will track it from there. It sounds like the perfect focus method but if your subject goes out of frame for a moment or turns around or something comes between the camera and them, **Tracking** is lost. Particularly good, therefore for a subject that will move around in a set space and will not be obstructed. I find it good for shooting bands in low light at wide apertures, where I can track the singers face accurately in spite of limited depth of field as he or she moves around the mic

- **225 Area** monitors the whole screen and puts focus at the most likely spot. Panasonic's algorithm for doing this is one of the best and it can be uncannily accurate. It gives the camera lot of work to do and for best accuracy it is good to limit the area it monitors as much as you can. To do that, with **225 Area** selected, press the down cursor and turn the rear dial. You can move the area around with the **Joystick**

- **Custom Multi** gives you an oval focus area and you can alter the size and position as with **225 Area**. The good bit comes when you highlight Custom Multi and press the up cursor button. You then have access to a horizontal and vertical pattern in addition to the oval. But best, you have three free-form custom patterns. Select one and press the down cursor button. You can now set an **AF Area** tailored exactly to your subject and its movement. For example, I find a pattern of four cells in a line spanning the centre of the screen ideal or photographing passing cyclists. I set this to **Custom 1** and choose it for suitable occasions

1-Area is my standard setting. I find it the most certain and controllable and very quick to focus on my subject. I find one size up from the smallest gives the camera a decent area to lock on to. At the smallest it is easy to find the camera trying to focus on a small blank area and, finding no contrast, hunting to find some. Using **1-Area** I half press the shutter to lock focus and then re-compose as necessary. I find that even quicker than shifting the **AF Area** around the screen with the **Joystick**

Pinpoint is great for macro mode or anywhere where you need a really precise positional focusing. It automatically enlarges the view so that you can set the cross hairs very precisely

Rec Menu

Aspect Ratio

4:3

gives you the maximum number of pixels/ biggest file size. It is the native sensor size and uses all the pixels available for an image.

3:2

is the old 35mm film camera ratio to which many photographers have become accustomed.

16:9

is widescreen TV/ Video aspect.

1:1

is the aspect of many older film cameras, usually 6x6cm in size and used by such cameras as Rolleiflex and Hasselblad. It is a rather awkward shape for most pictures but there are those who like it. It gives only a 14.5M image as compared to 20M at **4:3** since it crops the image to 3888x 3888. With **3:2** and **16:9** the G9 is simply cropping the top and bottom sensor image to get the ratio required and the pixel width of the image will always be the same at 5184 pixels. You could argue that it would be better to shoot always at **4:3** and the crop out any unwanted image areas but it is much easier in practise to view and compose the picture in the aspect ratio you have chosen.

Picture Size

This applies to the JPG files only. If you are shooting RAW, this will be blanked out because RAW always uses the full sensor area. It sets the number of Megapixels or MP your camera will record from the sensor. will record the most detailed image but take up

the most space on your SD card. This will give the
very highest quality prints, full commercial quality, up
to 18" across. In practise prints up to 30" across will
be excellent quality.

L 20m

M 10m

records less detail but also enable you to record many
more images on your SD card. Prints up to 18" across
will look good.

S 5m

records least detail but also enable you to record many,
many more images on your SD card. It's the best size
for images to be uploaded to social media but will
make good prints only up to around 12 inches across.
That's probably enough for most photographers but I'd
recommend always shooting at L 20m because you
can always discard excess detail. You can't add it,
though!

Quality

This controls the amount of compression applied to
JPG images. If you shoot **RAW+JPG** it applies to the
JPG file only. **RAW** files are always maximum
quality and cannot be changed. **JPG** compression
works by discarding image detail in an intelligent way
and is highly effective. The six blocks means less
compression and so larger files with more detail. Three
blocks give more compression and so smaller files at
the cost of less detail. If you plan to send images
directly to online destinations like Facebook, even the
higher compression three block setting will be fine.
The relationship between **Picture Size** and **Quality** is
often misunderstood. **Picture Size** gives a smaller file

size simply because there are fewer pixels. The G9's **Large** setting has 5184x3888 pixels, over 20 million of them. The **Small** setting of 2624x1968, about 5 million pixels and not surprisingly gives a file size 25% of that of **Large**. **Quality** on the other hand does not affect the number of pixels in the image but the amount of detail stored in the file. Where you have 10 pixels in a file, all very similar in colour, a JPG compression makes them all one colour and stores one pixel with information to repeat it 10 times, for example. Given the cheapness of storage, I would advise to shoot at maximum size/ minimum compression unless I knew my picture was only for social media. You can always discard detail for space saving later on but you cannot add it if you did not have it in the first place.

AFS/AFF

This controls the action of the **AF** setting position of the **Focus Mode** lever. It can be quite confusing. Let's say you are making a portrait of your young daughter. She is a bit fidgety. You press the shutter halfway and the camera focuses on her face. You hold the camera in position and wait a second until she smiles. Press the shutter and there is the picture. But what if she suddenly leans towards you at the very moment you press the shutter?

AFS

Focus is set when you half press the shutter. It remains locked while the release button is pressed half way. Though your daughter has leaned forward focus remains where it was before she moved and your picture will be out of focus.

AFF

Focus is set when you half press the shutter but the camera then adjusts the focus point continuously while half-pressed, following your daughter's movements until you finally release the shutter. The focus point had been shifted and your picture will be in focus. Although the **AFF** setting sounds the obvious choice, it can be a bit disconcerting on more static subjects. I use **AFS** as my normal setting, changing to **AFF** for portraits of children or animals who tend to move unpredictably. **AFF** is suitable for fairly static situations where any movement is likely to be limited. If the subject is running around, constantly moving and over a distance, you need **AF-C** set on the **Focus Mode Lever** or **Focus Tracking**, set on the F3 button.

AF Custom Setting(Photo)

This allows you to tailor the autofocus action to your specific needs when **Focus Mode** is set to **AFC**. Otherwise it is greyed out. **Off** is effectively these setting at their mid point **0**. I find **Set 1** a good all round setting, as it is intended to be. The other 3 settings are well chosen and explained and one of those should meet most requirements. **Set 2** would be suitable for motor racing, **Set 3** for football and **Set 4** for a dog chasing and catching a stick. If you have a cat, **AFS** will do! **Note:** It is impossible to give any specific advice about an adjustment such as this because the subjects, even the same ones, can vary so much. Photographing dogs at play, for example, a collie might require totally different settings to a labrador.

AF Sensitivity

Speeds up or slows down the rate at which focus changes as the subject moves. Set high, the focus reacts fast to any change so a 100 metre sprinter running towards you would be kept sharp. Set low, the camera is less willing to change focus so if a fellow sprinter drifts off lane in front of your man the camera won't suddenly switch focus. It differs from the next setting in that it applies to the sensitivity of the focusing action itself.

AF Area Switching Sensitivity

This comes into play more when you are using the **225-Area** or **Multi** area patterns. If the **225-Area** pattern is tracking your sprinter but he suddenly darts in a different direction to avoid a fallen runner, this sets how willing the camera is to let the camera adjust the focus pattern to a new area of the frame. Set high, as the runner swerves, the **AF Area** might switch focus to the background crowd. Set low, it will not react so quickly and since your sprinter will regain his lane as soon as possible, the **Focus Area** will stay with your man.

Moving Object Prediction

If you have a stillish subject which then moves suddenly - a tennis player serves and then rushes to the net is an example - you might use setting +1 or even +2 for an immediate response to their movement. Setting 0 might be better if the player was practising their serve and thus in roughly the same position for every shot.

Photo Style

This gives you a series of preset colour values other than the standard neutral output. Each can be customized with regard to **Contrast**, **Sharpness**, **Noise Reduction** and **Saturation**. I find all the default 0 settings good for my purposes except for **Noise Reduction** which at 0 is too aggressive for my taste. I set it to -5 since I am willing to accept some noise in return for maintaining sharpness.

Standard

Plain vanilla neutral values and the pick for general use.

Vivid

This is self-explanatory though I'd have called it Lurid.

Natural

Gives pleasantly soft colours.

Monochrome

Black and white! When this is set a new option appear on the right of the screen. It allows you to select red, green, yellow or orange filters. These are the classic filters used in film days with red being the most dramatic, yielding dark, almost black skies that enhance the dramatic effect of any clouds. You can also add grain effects.

L.Monochrome

This is a nice gutsy black and white, great for moody landscapes. Do try the filters with this one!

L.Monochrome D

This is an even more gutsy monochrome for those gritty urban landscapes.

Scenery

Bluer skies and greener greens.

Portrait

Warms the skin tones

Custom 1-4

Here you can set the G9 to record JPGs to your own specification in terms of contrast, sharpness, noise reduction, saturation (the intensity of the colours) and hue, the colours themselves. So, for example, if **Vivid** was not vivid enough you up the contrast and saturation sliders and save that as the new **Vivid**. You need to experiment with these to see what you prefer. The styles do not affect **RAW** files but if you set **RAW+JPG** you get a normal **RAW** plus the styled **JPG**, effectively giving you the best of both worlds.

Cinelike D

This is mainly used by video makers but you may like it for stills. It is flat in contrast and is intended to use as much of the dynamic range of the sensor as possible, retaining the maximum detail in the shadows and highlights. Then,for post processing you can tailor the image to your liking. For stills, if you are going to this much trouble, you might as well shoot RAW which retains everything the sensor records and offers you maximum flexibility on post processing.

Cinelike V

Like the previous entry, this is mainly for video use. It is intended to give film like images which to my eyes looks quite like **Standard** but with slightly denser colours, somewhere between **Standard** and **Vivid**.

Filter Settings

When you set the **Mode Dial** to **Creative Control** it not only applies the effect you choose, it sets the camera to **Program** mode, taking over control of shutter and ISO. If you set the G9 to another exposure mode, **Filter Settings** allows you to apply the same effects as **Creative Control** mode but using the settings you are currently using. So if you want great depth of field for a landscape or a fast shutter speed for sports, you can use **Filter Settings** to retain control of your G9 settings while the filter is applied. Note that this **does not** apply the filter to **RAW** files! The **RAW** file will show the filter effect when viewed in camera but when imported into your imaging software it will not be there. The reason is that a **RAW** file is what it says, **RAW**, uncooked data right off the sensor. If a filter were applied to it, it would no longer be **RAW**. To get the best of both worlds, shoot **RAW+JPG**, retaining the clean image but with the filter applied to the JPG. This will be done automatically. You cannot use **Photo Style** and **Filter Settings** together. If you set a **Filter Setting**, it will set **Photo Style** to **Standard** and grey it out.

Filter Select

Make your choice from the 22 **filters** (effects, really) available. Some effects have a moveable component, **One Point Color**, for example, to choose the colour to retain. To access them press the **Up** cursor. Any adjustment or movement will then appear with on screen with instructions if needed. It's always worth

39

pressing the cursor to check if any adjustment is possible. With **One Point Color**, line up the yellow box that appears on pressing the cursor with the colour you want to retain and press **Set**.

Simultaneous Record W/O Filter

This is a useful facility which is only available when **Quality** is set to **JPG**. One press on the shutter makes 2 pictures, one with the filter in operation and one without so if the effect doesn't look good you haven't lost your picture. Note: If you load both filtered and unfiltered images into layers in Photoshop (or any image program with layers) you can blend the two, making the effect more subtle. If you are in **Burst Mode** or **Auto Bracket** when you set a filter, your G9 will revert to single shot.

Color Space

sRGB

This is a world wide standard for colour space and is best for digital images, general printing and Internet use.

Adobe RGB

This is more specialized and mainly for professional use. If you are working for the print industry, they may prefer this but without special software or a specialized professional(and expensive) monitor it can tend toward dull colours. It does not increase the number of colours the camera records! Use **sRGB** always except when **Adobe RGB** is requested. If you shoot **RAW** files **Color Space** is irrelevant since you choose the **Color Space** in post processing.

Metering Mode

This sets the way in which the camera reads the light falling on your picture

Multiple

Multiple, the whole screen is read and the camera judges the exposure for you. In my experience the **Multiple** setting is very reliable and even when it does err it is not by very much.

Center Weighted

Center Weighted weights the exposure to the centre of the screen on the reasonable assumption that that is where the subject is. It was a method used by film cameras and remains for legacy reasons more than anything else. In practice **Multiple** does everything **Center Weighted** does but better and more intelligently.

Spot

Spot Metering measures the exposure from the centre of the screen. A small green cross appears on the screen to tell you it is spot metering. This works best when the lighting is extreme. For example, you are photographing a bird sitting on a telephone wire with a bright blue sky behind it. The camera on **Multiple** will try to set a compromise exposure by balancing the bird with blue sky light reading. It cannot know that you

care only for getting detail in the bird's plumage. Set to **Spot** and it will expose for the bird. This metering mode can be tricky, requiring experience to use. In a situation as outlined, I prefer to use **Exposure Compensation** to add a stop or so or otherwise use the **Auto Bracket** setting.

Highlight Weighted

is the same as **Multiple** but it biases exposure towards the highlights to meet commonly encountered situations in which **Multiple** will not give the best result. Imagine a music concert where the singer is centre stage in a spotlight with the band around him or her on stage. Normal metering will overexpose the singer because it takes into account the unlit areas surrounding the players. This setting tells the G9 that the important part of this image is the highlights and it adjusts the exposure accordingly.

Highlight Shadow

This does not operate on **RAW** files. This is an advanced option which lets you set the tonal response of the camera to your personal requirements. If you find your images are consistently of lower contrast than you want, for example, you can set the curves so that the contrast is raised or areas of the image lightened or darkened. There are a series of presets and also three **C**ustom settings which you can set and recall for later use. The first, leftmost preset resets the response to default. You can alter the tone curve by touching the presets along the bottom of the monitor, dragging on screen or using the front and rear dials. I can't see many photographers using this facility since the G9 takes care of the tone curve so well

automatically. However, if you use a studio regularly, say, and found your results consistently flatter, less contrasty than you like, you might save an option here to correct that. If you do use it regularly, probably best to set it to a **Fn** button. It is not something to be applied generally so easy **On/Off** access will be necessary. **Highlight Shadow** effectively alters the contrast of your image but whereas a contrast control operates on every brightness level on an image, this gives you separate control of the low and high levels and is much more versatile. Handily, the settings are shown in real time as you alter them. This is a control that will be rarely needed but when it is can save a lot time in post processing.

i.Dynamic

This tweaks the exposure and contrast on scenes with extreme lighting differences. Disabled in **RAW**. It has three levels which are nicely progressive in effect. The outcome of **iResolution** is difficult to predict so I suggest where possible to shoot the same scene at all settings and pick the best afterwards. If you don't have time to do that, **Auto** generally makes a decent job of it.

i.Resolution

This tweaks the sharpness setting. Disabled in **RAW**. I find the standard **G9** sharpness settings excellent so don't use this because over-sharpened images, while sometimes superficially attractive, can also appear harsh and unnatural.

Flash

This is available only if you have a flash fitted and switched on. **Flash** does not work with the **Electronic Shutter**. **Flash** operation has 3 pages of its own though the third page only appears when **Wireless** on page 2 of the menu is turned on. **Note:** with all but the simplest flashes the **Firing Mode** will be set on the flash itself. If it is greyed out, that is the reason.

Firing Mode

TTL

The camera takes care of the flash output automatically. (I use this setting all the time unless forced to use manual)

Manual

You can set the level of the flash output yourself using trial and error or using the flash guide number if **TTL** does not do the job to your satisfaction. You can set the output level of the flash in manual operation by going to the next page (Page 2) of the **Flash** Menu under **Manual Flash Adjust**. Normally, luckily, **TTL** takes care of it all.

Flash Mode

The flash fires regardless of lighting conditions. The shutter speed can be set up to 1/250th Sec. Handy for backlit sunlight portraits for example. You will actually see two flashes, the first, less strong one being the pilot flash for the camera/ flash to judge

the exposure necessary. The flash fires regardless of lighting conditions as in the first option but fires a couple of pre flashes to reduce red-eye.

Slow Sync. This is effective to balance flash on a foreground subject with natural light on the background. Usually, you'll need to mount the camera on a tripod for this as it will often need slow shutter speeds. If you are photographing someone or something in a darkish room in **A** mode with an ambient light level of 1/15th @ f/2.8, with normal flash sync, the shutter speed will not drop below 1/60th. Your subject, in the foreground will be correctly lit by the flash but the background will be dark. With **Slow Sync** set, the shutter speed will drop to the required 1/15th so that both the subject and background will be correctly exposed. **Note:** With this setting, the shutter speed will be allowed to rise above the 1/250th maximum that camera can sync to the flash. In this case, the flash simply doesn't fire.

Slow Sync with red-eye reduction.

This disables the flash regardless of any other settings. A use for this would be for a wedding photographer, for example. Set the **Flash Mode** to a

function button so that if you are photographing outside using fill-in flash to lighten shadows but flash is forbidden in the church you can have peace of mind of knowing that even if left on, the flash will not fire.

Flash Synchro

1st

If the exposure is 1 second, for example, the flash will fire at the beginning of the exposure and any blur will appear to be in front of the moving object. This will look rather odd.

2nd

The flash will fire just before the shutter closes, motion blur will be appear behind the moving object and give the effect of speed. In general use, leave it on **1st** but mixed flash and daylight exposures can be very pictorial. Try standing someone so that there is a clear view of a sunset behind them. Use **S** mode and an exposure of 1/10th at whatever aperture the camera sets. Have the subject move a little during the exposure. It gives a neat double image effect. There is a lot of opportunity for exciting pictures with combined flash and natural light.

Flash Adjust

This alters the overall strength of the flash to your taste. If in your opinion your flash lit pictures are too light, set it to a minus setting. Too dark, set it to a plus setting. For most people, the camera will get it about right without any compensation. Sometimes, with a strongly backlit outside portrait, the flash can overpower the natural light and give an artificial look to the picture. With a little experimentation a minus

flash adjustment of 1/2 or a full stop can disguise the fact that you used flash at all.

Auto Exposure Comp.

With this **Off**, any **Exposure Compensation** set will affect only the ambient light. Set **On** both ambient light and flash level will be changed. If have a subject in a dimly lit room and you want the room to be lighter in comparison to the subject, leave this **Off**. Now, if you set the **Exposure Compensation** +1 stop, the room will be one stop brighter but your subject remains the same. If you feel your overall exposure is too dark or light set this **On** and the overall image will be lightened or darkened/

Manual Flash Adjust

If you have the flash **Firing Mode** (see above) set to **Manual** this enables you to vary the power of the flash to your needs. You can drop the power to 1/64th of maximum. This is a very precise way of setting the flash to exactly the intensity you want and is especially practical with inanimate subjects. Less so with moving ones since you are unlikely to be able to alter the settings fast enough. The flash power is cut by shortening the duration of the light pulse. If you want to photograph a moving object in dim light without blur, firing the flash at low power is an effective way to do so. In a highly sophisticated form, it is how many of the professional pictures of subjects like bees in flight with their wings apparently still are made. The exact speed of the flash pulse will depend on the flash in use, of course. Note: if your flash has

a **Manual** mode, this will be greyed out and control is from the flashgun.

Wireless

You can use a flash in the G9's hot shoe to trigger a remote flash or flashes. This is called wireless flash. When set **On** the following menu items appear.

Wireless Channel

If you are using a wireless flash it will have 4 operating channels. You set the remote flash and camera to the same channel.

Wireless FP

With certain wireless flashes this makes possible the use of a higher shutter speed than the 250th second of a standard camera flash. The reason you cannot use a faster shutter speed than 1/250th with flash normally is that the flash pulse time is shorter than the time it takes the shutter to travel across the sensor. Therefore only a narrow band across of the subject shows as lit by the flash. FP works by firing a series of flash pulses in rapid succession.

Communication Light

The flash in the camera hot shoe which triggers the external flash also gives off flash light. If you want your external flash to be the main subject lighting this trigger flash can show up on the subject and interfere with the main light. You can minimize the effect of the trigger flash by reducing its power using the **Communication Light** setting. If set too low, the main light will not be triggered, of course. Many accessory flashes (Metz, for example)come with a cover for the hot shoe flash which blanks off the light while still allowing the trigger pulse through.

Wireless Setup

This is beyond the scope of my book and will be explained more fully in the manual of the wireless flash itself. Basically, you can control the firing method and relative power of the inbuilt flash and up to three external units from here. With 3 external flashes you could have a full power key light, half power fill in and quarter power background, say. You have individual choice of the mode of operation of each flash or switching it off altogether. Personally, I would set the Firing Mode to Manual and set each flash myself, doing test shots until I nailed the exact result I wanted. It would take time but such a setup could be used over and over again to give reliable multi-flash studio style lighting out in the field. Test by pressing the **Disp** button on the camera back or touching **Test Flash** on the monitor. Complicated but an invaluable facility to have. In reality, complex flash lamp setups are difficult to work with and most photographers will find it easier and more reliable to use two or three studio lights on stands. With these, whether flash or LED you will have proper modelling lights built in so that you can judge your setup by eye.

Red-Eye Removal

when the flash is set to either of the red-eye reduction

settings or , if the camera detects any residual red-eye it corrects it automatically.

ISO Sensitivity (photo)

This sets the minimum and maximum ISO settings that the G9 can choose when set to **Auto ISO** or **iISO**. **iISO**, by the way, is like **Auto ISO** but it takes into account the type of subject you are photographing when choosing the setting. It is likely that you will find an ISO setting where the noise is too high for your taste. If it is ISO 6400, then setting **ISO Upper Limit Setting** to 3200 will prevent the camera from straying that far upwards when set to **Auto**. Similarly, if you find that you prefer to use high shutter speeds, setting **ISO Lower Limit Setting** to, ISO 800 will keep the shutter speed up. I find a lower setting of 200 and a higher one of 3200 keeps the image quality within acceptable bounds for my work. If you want to use a ISO 12800, you can set it manually whatever the upper or lower limits you set here.

Min Shtr Speed

When **ISO** is set to **Auto**, there is always the possibility that the G9 will will lower the shutter speed rather than raise the ISO under certain conditions. If you set **Min. Shtr Speed** to, say 1/125th, the camera will be forced to raise the **ISO** rather than drop the shutter speed to 1/60th. Therefore, you will know that, if you are using a telephoto lens, the camera will not set a shutter speed too low for you to hold still. This can't work miracles, of course. If there is not enough light to maintain your 1/125th minimum, the camera can't manufacture more light so will drop the shutter speed as necessary. This just forces the drop in speed to below 1/125th to be the last resort.

Long Shtr NR

Removes noise from frames taken at long shutter speeds, night scenes, for example. In low light and at long exposures the image sensor generates noise of its own. **Long shutter NR** very effectively lowers that noise but due to the way it operates doubles the time for capture of an image. If you have an exposure time of 10 seconds, the camera will be processing for 10 seconds after the exposure. I would never turn this off unless I really had to. It works by taking a second reading of the sensor with the same exposure length after your picture and looking to see where noise has been generated. It then subtracts that noise from your picture, cleaning it up.

Shading Comp

Corrects vignetting or darkening of the corners of the picture with some lenses. If you have a lens that vignettes enough to bother you, try this. It adds a small overhead to the time taken to write images to your SD card and can make the lightened areas more noisy in extreme cases, so is probably better left **Off** if not needed.

Diffraction Compensation

When you pass light through a very small hole it bends it. This is known as diffraction. When you stop an MFT lens down to a small aperture, say f/8 and beyond, the aperture (or diaphragm) becomes small enough to diffract some of the focused light of your image. This causes the image to look 'soft' or slightly blurred. It is an optical phenomenon and nothing can be done about it except to apply extra sharpening to

the image which is what **Diffraction Compensation** seems to do. While it improves the apparent sharpness, as with any digital sharpening it can highlight noise in the image. Micro Four Thirds cameras are more prone to image diffraction than larger sensor cameras because the lens focal lengths it uses are smaller (25mm instead of 50mm for a normal angle of view, for example) and so any given aperture is smaller. The aperture size for a lens is given by dividing its focal length by the aperture. Thus a 50mm standard lens at f/8/ has an aperture diameter of 50/8 or 6.25mm. A 25mm lens at f/8 has an aperture diameter of 25/8 or 3.125mm. Hence, more diffraction. If you can avoid it, don't stop a Micro Four Thirds lens down beyond f/8. Most are at their very best at f/4 or f/5.6. **Diffraction Compensation** is subtly implemented on the G9 and well worth leaving at **Auto**. As an interesting side issue, a pinhole camera uses a small enough hole that light passing through it is diffracted enough to focus the light without the need for any glass lens. The results are interesting - but less than crisp!

Stabilizer

Operation Mode

This enables you to set the mode of stabilization you

require. Normal stabilization correcting all

shake. Turns off lateral correction for when you are using a panning action (ie moving the camera

to follow the subject). Otherwise the camera will attempt un-pan your careful panning. The **OFF** option only appears when there is no on/off switch on the lens. When shooting from a tripod, stabilization is best switched **Off**. It can also be beneficial to switch it **off** when shooting sequences of moving subjects. You will be using a high shutter speed so probably won't need stabilization. Stabilization needs a lot of processing power so it makes sense to free up as much as possible for the focusing routine. **Note:** Many lenses have their own inbuilt stabilization and the G9 will enhance the stabilization available by combining the body and lens capabilities where it can. In practise, all unstabilized lenses will use the body stabilization. Olympus lenses with stabilization will use only the G9's stabilization and will not combine them. Panasonic lenses with stabilization will combine automatically with the camera to enhance the capabilities. This called **Dual Stabilization**. You do not have an option to use one or the other except with a few older Panasonic lenses. In these cases, you can switch either stabilization **Off** but in reality the G9's in body stabilization is better than the lens's so switch **Off** lens.

E-Stabilization (Video)

This adds extra stabilization on top of the normal for video only. It restricts the angle of view of the lens to give itself leeway to shift the image around on the sensor. I find the normal lens/body stabilization adequate for video but this is useful for use under extreme conditions, hand held walking shots, for example, where a jittery or jarring motion is imparted.

I.S. Lock (Video)

This is for video use only. It steadies the camera to the extent that sequences can look like they were shot on a tripod. It works less well with telephoto lenses. For it to work you must hold the camera in a fixed position. If you want to re-frame or zoom or move, you need to turn the **I.S.Lock** off while you do it. When it is in use, a hand icon will appear on screen to remind you not to move. Provided you accept the limitations, this is stunning facility to have for improving your video.

Focal length set

If you are using a non Micro Four Thirds standard lens it will not have the correct contacts to set its focal length automatically. When you fit such a lens, the camera will ask you to set the focal length so that it knows what stabilization to apply. You can save 3 focal lengths in the box below the selector. To do this, select the focal length and then press the down arrow. Highlight the preset you want to replace, and press display. Confirm the dialog that appears and that focal length is now one of your presets. If you are in any doubt about how effective this is, set it to 8mm with a 300mm lens fitted!

Ex.Tele Conv.

This basically works by cropping the sensor. In these days of high quality and relatively cheap zoom lenses, it is a bit of anachronism for stills. You might as well shoot the full image size and crop later to taste. It has more validity in video where it increases the image size without quality loss. It is set separately in the **Movie** menu.

Digital Zoom

This crops the sensor but differs from **Ex. Tele Conv.** in that it up-samples the result to full image size. Again, a bit of an anachronism with modern equipment and the up-sampling process inevitably impairs sharpness. Better to shoot in **L**arge and crop, only up-sampling in the unlikely event of viewing on an unusually high resolution monitor and a very large print. Preferably, just turn the zoom ring a bit!

Burst Shot 1 & 2 Setting

The G9 has an impressive array of Burst settings. **Burst I** and **II** let you pick your two most used settings and assign them here for immediate access. The **Burst** settings have become quite complicated with the G9. **Note: 1. Live View** means that the image in the EVF is where the subject is at the moment the frame is shot, in other words you are viewing in real time. When **Live View** is not possible, the image in the EVF is the frame just shot, so lags just behind real time. Some people find the lag disorientating, some don't. I do, so prefer the settings with **Live View** available. 2. When I say **MSHTR** that includes using the **MSHTR** with **Electronic Front Curtain**. 3. When set to a **Burst** mode, if you half press the shutter you will see a lower case 'r' appear on the right of the **LCD Status** panel or the monitor **Info Disp.**. The figure following is the maximum number of frames you can fire at the present **Burst** setting.

• **SH2** automatically uses the **ESHTR**. It cannot use the **MSHTR**. If you set the Focus Mode to **AFS** or **MF** you will get **60fps**. If you want to follow focus so set the **Focus Mode** to **AFC** (or **AFF**) you will get **20fps**. The maximum number of frames you can fire off is **50** and that applies with both **JPG** and **RAW** files. You can't have **Live View** with **SH2** but given the short duration between frames the lag, while not ideal, can be coped with. If you set **SH2 PRE** with **AFC** or **M** you save 24 frames from before the moment you fire the shutter. With **AFC** or **AFF** you get 8 frames. This sounds miraculous but what happens is that when you half press the shutter, the camera starts shooting. When you actually press the shutter, it saves the 24 (8)frames preceding the full shutter press and the subsequent 26(42) after the shutter press. You still get a total of **50** frames.

• **SH1** - the **ESHTR** again. This gives you **20fps** regardless of the **Focus Mode** which allows you to shoot **AFS** or **M** at 20fps rather than the 60 of **SH2**. Again,no **Live View** and **50** frames max. **SH1 PRE** gives you the 8 frames preceding the shutter press.

• **High** - allows you to choose either shutter. If you have fast moving subject you can avoid any danger of the jello effect by using the **MSHTR**. Shooting speed and **Live View** availability depend on the **Focus Mode** setting. **AFS** or **M** gives you **12fps** without

Live View, **AFC 9fps** with **Live View** Using **RAW** you can shoot around 60 frames per burst, with **JPG** 600 or more. This is under ideal conditions. In reality the burst speed will slow.

• Medium is refreshingly simple - **7fps** with **Live View** whatever the setting with 60 or 600 pix recordable as with **H**

• L - same as **M** but **2fps**

• **Note:** I find **7fps** or **9fps** sweet points for sports shooting. They are fast enough to capture the action, don't overload the G9's processor so follow focus well and give a manageable number of frames for selection and editing. They are best for subjects like football or motor sport where your subject is moving fast and/or erratically. The higher frame rates, which restrict you to AFC, are more suitable for a subject like a hurdler moving directly across your field of view. You can focus on the hurdle and shoot a high speed sequence as the athlete jumps and thus be sure of catching a good action moment. For sport you will be shooting at a high shutter speed so won't need stabilization. Switch it off along with any other computer sapping functions like **Shading Comp.**.

6K/4K Photo

For this to take effect you must set the **Drive Mode**

Dial to To realize highest speed results you will also need a fast UHS Class 3 SD card. These are the ones with a double row of contacts. They are backward compatible with older SD Card readers. **Note:** the Aspect Ratios available are 4:3 and 3:2. The **6K/4K** bursts will be in the **Aspect Ratio** currently set. If you wish to change it, go to **Aspect Ratio** in this **Rec** menu or on the **Monitor Info. Disp.** Because these high speed modes use the electronic shutter (**ESHTR**) images may be subject to a movement distortion commonly called the jello effect. Focusing is automatically set to **Continuous**, the only other option being **Manual.**

Picture Size / Burst Speed

The choices here are straightforward. 6K offers a 4992px wide image at 30fps. 4K gives a smaller 3328px wide image but offers 60fps as well as 30. The sequence is recorded as an **MP4** movie file. You can extract the files you want to keep by pressing the **Playback** button and viewing the file. A touch on the

monitor will bring up this icon. Touch it and a series of controls comes up, enabling you to scroll through the frames, pin them for later retrieval and

extract and save them by touching this icon. When you do so, a confirmation dialog appears. At the bottom of the screen you will see **DISP.Reduce Rolling Shutter**. Touching this will have the G9 try to correct any of the rolling shutter (jello) distortion inherent when using the **ESHTR**. It will often say that it cannot correct this image but even if it does accept the image, its results are unpredictable, I find.

Rec Method

- The burst will start when you press the shutter button and finish when you release it.

- Press the shutter button to start the sequence which will continue until you press the button again.

- The shutter button acts as if you are shooting a single shot so press it at the moment you want to capture. However, the G9 will record 1 seconds worth of the action from before you press the button to 1 seconds worth after, at your chosen frame rate. This sounds

like a miracle but what it actually does is record constantly from when it is set. Then when you press the button, it saves the frames from before and after pressing. It is a great way of shooting something that happens very fast and suddenly, such as a bird landing on its nest. You can do the same thing with the other 2 **6K/4K** burst settings but you then have hundreds of frames to go through to find the right one. With **Pre-Burst** all the frames are relevant and you just have to pick the best.

Pre-Burst Recording

This isn't available in **Pre-Burst** (above) which performs this function as part of its routine. With **Burst** and **Burst(S/S)** this gives you the images from 1 second before you press the shutter button. Again, it works by setting the camera recording from the moment it is set. Both this and **Pre-Burst** drain the battery quite quickly because the camera is recording all the time, so they shouldn't be used to simply shoot everything and pick afterwards. Besides, given potentially thousands of frames to from which to select, you will suffer from editing fatigue and quite likely miss the best shots! Panasonic warn that the camera may overheat if these **6K/4K** used excessively. So don't forget to turn the **Drive Mode Dial** to a normal shooting mode as soon as you are finished. You will see **Pre** on the right of the monitor when this is in action.

Post Focus

If you set the **Drive Mode Dial** to this item simply gives you the choice between **4K** and **6K** files. I give details of the operation of **Post Focus** itself in the Controls section of the book.

Self Timer

delays the firing of the shutter for the specified time.

10 seconds gives you time to get in the picture yourself.

gives a 10 second delay and then takes 3 pictures at about 2 second intervals. If you are taken by surprise by the first shutter click, you have two more in which to compose yourself.

This is useful for letting the camera settle down after the shutter button has been pushed. It can be used instead of a cable or remote release on a tripod but is also surprisingly useful for long hand held exposures, enabling you to remove your finger from the shutter release and settle the camera tightly against your body

with both hands. See also the **Shutter Delay** setting in the **Rec** menu which is similar but tailored to firing the shutter with the least possible shock.

High Resolution Mode

This is new to Panasonic cameras. The G9 has in body stabilization (**IBIS**) which works by holding the image sensor in a magnetic field and shifting it to compensate for body movement. **High Resolution Mode** works by shifting the sensor 8 times and making an exposure at each point. It then stitches the images together to render an 80Mp image (at **4:3**) of 10368x7776 or a 40Mp image of 7296x4864 pixels. This takes several seconds to complete. Your final image will enable top quality prints 3 to 4 feet across. You have the option of **3:2**, **16:9** and **1:1** aspects too. **Note:** all stabilization will be turned off automatically while the routine is carried out but if you have an Olympus lens with built in stabilization you should turn it off yourself. The camera must be on a tripod or totally immobile when shooting otherwise the reason for making the Hi-Res image, the sharpness, will be lost. Any movement in the image whether a person or trees in the wind will present as blurred.

Start

Pressing this sets the camera for the Hi-Res shot. Now, when you press the shutter button, the screen will go blank and you will hear a series of shutter clicks followed by a notification that the Hi-Res image is being created. The G9 will take a new Hi-Res picture very time you press the shutter button. When you've finished pressing **Fn2** will set the camera back to normal resolution operation.

Picture Size

Choose **LL** 40Mp or **XL**, 80Mp. **XL** is great for landscapes. You can frame a little less tightly than you normally would and finalize your composition in post processing.

Quality

Set the compression or quality of your **JPG** and whether you want to shoot a **RAW** file at the same time. It makes little sense to shoot a **HiRes JPG** and then lose quality by highly compressing it!

Simul Record Normal Shot

High Resolution Mode works by shooting 8 slightly offset frames and combining them into one larger one and discarding the originals. Set **On** this keeps the first frame so that you have a normal resolution image as well as your **HiRes** one.

Shutter Delay

A small amount of movement can ruin a **HiRes** shot. Pushing the shutter button can jog the camera so introducing a shutter delay gives it a chance to settle down. A couple of seconds should do the trick.

Motion Blur Processing

Mode 1 shows any movement in the subject, leaves waving in the wind, for example, as a simple blur. **Mode 2** attempts to process any blur to minimize its impact on the shot. Ideally, use a tripod and shoot when there is no movement within in the frame, of course.

Time Lapse Animation

This enables automatically taking pictures at set intervals, key to time lapse and animation techniques. You can set up the parameters at any time but you

must set the Drive Mode dial to to activate them.

Mode

This sets **Time Lapse Shot** or **Stop Motion Animation**. The difference in operation is that **Time Lapse Shot** fires off the chosen number of frames at the chosen interval and then stops whereas **Stop Motion Animation** can fire at a chosen interval or manually and overlays the last two frames taken so that you can visually judge how far to move your subject for each consecutive frame. Both methods are compiled into a movie after shooting. **Note:** I'd suggest using the **ESHTR** for these operations to conserve battery power and prolong shutter life. With a projected life of 200,000 operations, at 30fps that equates to less than 2 hours of movie!.

Time Lapse Shot

This gives you those stunning effects seen so often on TV documentaries, where the sun moves across the sky or a building in 20 seconds or rush hour crowds zoom past the camera as if on wheels.

Start Time

Once you have set the parameters below either press **Now** and then the shutter button for an immediate start or **Start Time Set** to set the time you want it to commence. Let's say you wanted to make a **Time Lapse** sequence of the moon rising and setting over your house. You could set the **Start Time** to commence shooting in 8 hours and the **Shooting Interval** to 10 seconds with an **Image Count** of 2160.

That would give **Time Lapse** movie of 2160 frames which at at 30fps would give you a video duration of 1m and 12s.

Shooting Interval

How often the shutter should fire.

Image Count

How many images it should take before stopping. **Note:** To interrupt or stop the operation prematurely press **Fn1**. **Note:** at the bottom of the setting screen there is information to tell you what time and date your sequence will finish.

Stop Motion Animation

Do you want to make a pudding crawl? A teddy bear do the tango? This menu item makes it as easy as it can be. **Stop Motion Animation** is akin to **Time Lapse** but as I said previously after each frame it shows the last two frames overlaid, so you can judge easily how much you want to move your pudding or teddy0 bear.

Add To Picture Group

This will bring up previous **Stop Motion Animation** groups (that is, sets of **Stop Motion Animation** stills, not MP4s) stored on the SD Card so that you can add the new one on to them.

Auto Shooting

You can either have the camera fire the shutter automatically at set intervals or fire it manually yourself. If the movement to be carried out is repetitive and simple, just set the **Auto Shooting On** and move the object of movement incrementally with reference to the overlays. If the movement is more complex, set this **Off** and fire the shutter by hand.

Shooting Interval

If you have set the camera to **Auto Shooting On**, choose how long to pause between frames while you adjust as necessary. **Note:** For complicated movements where you are making the adjustments and firing the camera yourself, it saves time to put the camera on a tripod and operate it remotely with your phone. Then you can sit near your move object just just out of shot, move it and fire off the shot immediately.

Silent Mode

This could have been called stealth mode! It switches to the **Electronic Shutter**, turns off any shutter sound set, switches off the flash and system beeps etc. The only sound is the soft rustle of the aperture blades. It can be set to a **Fn** button and can be memorized in **Custom** modes. A very handy function for any situation where photography might be considered obtrusive or a lightly sleeping baby might be woken up! It differs from **ESHTR** in that all signs and sounds of camera operation are suppressed. With the **Electronic Shutter** you can attenuate the shutter sound but beeps and any flashing lights continue to operate. The only indications of the presence of the camera are the **On** light, plus the **Self Timer** indicator if used and **Wi-Fi** blue indicator light if in use.

Shutter Type

The G9 has eliminated the dreaded 'shutter shock' according to my tests. Shutter shock was an effect occurring at shutter speeds between 1/60th and 1/400th (roughly) where the force of the shutter's first curtain hitting the frame edge would cause a slight double imaging or blurring. A .44 Magnum round at about

1,000mph would travel about half an inch at the 1/32,000th top speed of the **ESHTR!**

Auto

The G9 chooses the most appropriate shutter type depending on your current usage.

MSHTR

The mechanical shutter. It can give speeds from 60 seconds (using Bulb and **M** mode) to 1/8000th and can be used with flash.

EFC

A hybrid shutter action where the first operation is electronic and the second mechanical. It was first used on Olympus cameras as a way of eliminating shutter shock. It effectively eliminates any possibility of shutter shock, the disadvantage being that the top shutter speed is restricted to 1/2000th. It can be used with flash You could use this all the time but in strong light and at the wider apertures often used in Micro Four Thirds photography, it is easy to find the top shutter speed a limitation.

ESHTR

A fully electronic shutter action. It can be totally silent or you can assign sounds to it (see later in this book) and it has a highest speed of 1/32000th. Why not use this all the time? Because you cannot use flash with it and any movement in your image can be prey to the 'jello' effect, a kind of sloping distortion due to the way the shutter operates. The G9's **ESHTR** is much less prone to motion distortion now and I tend to use it as standard. It uses less battery power but needs care under fluorescent light, where it can cause a banding effect. **Note:** There is a logic to using **Auto** all the

time but I am never sure if or when camera will switch to the **ESHTR** and potentially spoil pictures with the jello effect.

Shutter Delay

When you press the shutter it will be delayed for 1, 2, 4 or 8 seconds. While it seems similar to using the **Self Timer**, it is specifically intended to let the camera stop shaking after the shutter button has been pressed. Apart from having a greater selection of delays than the **Self Timer**, it fires the shutter in a way that minimizes disturbance. This is for tripod use only since unlike **Self Timer** the monitor or EVF blank out while the countdown takes place. This is intended and necessary in order to fire the shutter in as vibration free a way as possible. Used with the **Electronic Shutter** it is practically as effective as using a remote release. I sometimes use this to steady the camera for long exposures when hand held, provided I am solidly set in position.

Bracket

Bracket Type

(Exposure Bracketing) Where light conditions are difficult, for example on a sunny day with someone half in and half out of a shadow, it can be difficult to know the correct exposure. Do you expose for the dark area, making the light area too light or the light area making the dark area too dark. Or somewhere in between? The camera's auto exposure cannot make this decision for you and it will

try to find an average. This is not always the best decision. At its simplest with **Exposure Bracketing** the camera takes three frames one after another, frame 1 at what the auto-exposure thinks is the correct exposure, frame 2 at half that exposure and frame 3 at double that exposure. You decide which exposure you like best after viewing the three exposures.

More Settings

gives you access to three parameters for **Exposure Bracketing**. Set to 7-1 it takes 7 frames one stop apart giving you a range from 3 stops under to 3 stops over exposure. 7-2 spans from 2 stops under to 2 stops over. 5 and 3 Step pro rata. You can see all this on the excellent graphic at the bottom of the **Auto Bracket** setting Screen. I find Step 3-1 the most useful. The G9's meter is rarely far off optimum exposure and if it is, frames 1 stop under and 1 stop over are usually enough. **Single Shot Setting** lets you set a burst mode so that instead of having to press the shutter button for each exposure, you can just hold the button down and they will be fired off sequentially until done.

 (Aperture Bracketing)

this will vary your aperture either side of your chosen setting. Set to f/5.6 and an **Image Count** of 3, it will give you shots at f/5.6, then f/4 and then f/2.8. Set **Image Count** to 5 and f/5.6 it will give you f/5.6, f/4, f/8, f/2.8, f/11. Set to **All** it will fire off shots using every **Aperture Setting** available from the widest to the smallest. Note that this will **not** alter your exposure which will remain constant. It will alter your depth of

field, how much of your picture will be in focus or how blurred your background will be. Take care with this facility because while your shutter speed might be perfectly manageable at f/4, at f/22 the camera may have to set a slow shutter speed that is not easily handheld, 5 Axis Stabilization or not!

FOCUS

This takes a series of frames with the focus point shifted each time. For any given subject it is difficult to predict what steps and how many you will needs so you'll probably end up finding the best result by trial and error. **Step** sets the amount by which focus will be shifted in each shoot. This takes into account how far the subject is from the camera. The nearer the camera, the shorter the distance between the focus points since depth of field is more restricted the closer the subject is to the camera. **Image Count** is simply the number of images you wish to shot. You can take up to 999 but I doubt there are many subjects that would require over 100. **Sequence** determines the order of shooting the sequence. **0/+** Starts at the point where you have focused the lens and focuses progressively further away. **0/-/+** takes one at your focus point, then one closer and one further away until your **Image Count** is fulfilled. **Note:** These focus bracketed frames can be used for **focus stacking**, a technique widely used to extend depth of field for photographs of small objects, insects etc. It entails combining the focus bracketed images into one image exhibiting great depth of field which would be unobtainable with a conventionally taken macro shot, even with the lens stopped down.

Most photo editing programs will perform the stacking.

WB *(White Balance Bracket)*
this is redundant in **RAW** since you set the **White Balance** to your own taste in software afterwards. **More Settings** lets you **Bracket** A-B or M-G. A-B shoots one normal, one warmer, one cooler frame. M-G (Magenta/ Green) varies the tint of the image. **White Balance** is sometimes called Colour Temperature. The setting is necessary because whereas the eye (the brain, actually) compensates for lighting conditions in the real world, when it looks at an image it just sees what is there. Thus, on a clear day at midday natural light is quite blue. In the evening it becomes redder. Because the brain knows this from experience, it applies a correction so that a red object looks the same tone at midday or at 8 in the evening. The camera, however, can't do that and pictures taken at midday look bluer (cooler) than pictures taken in redder (warmer) late evening. **Auto White Balance** is the camera's answer to the brain's inability to automatically compensate for over cool or warm images in a photograph. It is (occasionally) fooled and Bracketing is designed to let you choose the best alternative. A-B bracketing is useful in daylight, M-G more so in artificial light from fluorescent tubes for example.

(Colour Temperature Bracket)

Not applicable in **RAW**. This brackets colour temperature in explicit terms of Degrees **K**elvin which is a scientific measure with absolute zero at -273K. Applied to photography, light from a candle will be around 2000K, very warm. In the shade on a day with a clear blue sky at noon, you'd have 8-10000k. This item does the same job as A-B (above) but lets you explicitly set the colour temperature in degrees Kelvin yourself. If I was unsure what colour temperature I wanted to set, I'd be inclined to shoot **RAW** which would enable me to choose any temperature I wanted in post processing.

HDR

High **D**ynamic **R**ange. The dynamic range of a scene is the range of brightness from dark to light. If you have a black dog sitting in front of a white painted wall on a sunny day, the dynamic range is very high. If the dynamic range of the scene is greater than the sensor's ability to capture it you will have to decide which element of your picture, the dog or the wall is more important pictorially and expose for that. Or, choose a compromise between the two. Unfortunately, there are many occasions when the dynamic range of a scene is simply too high to capture satisfactorily. That is where **HDR** comes in. It takes 2 or more frames and blends them in such a way that detail is retained in both dark and light areas. It can't work miracles and results can look unnatural or downright ugly if overdone. The G9 has a very good **Auto** algorithm

under **Dynamic Range** but if the results of that are not what you want, the supplied explicit **EV** values are worth a try. Start with 1EV and work upwards. **Note:** Since **HDR** works by shooting several frames and blending them, any camera movement will lead to blurred results. A tripod is advised for best results. The **Auto Align** does a good job of minimizing the effect of camera movement but it is at the cost of a narrowing of the lens's angle of view and can only do so much. **Note:** Shooting **RAW** allows maximum access to the camera' dynamic range. If you shoot the pix **RAW**, you can export copies of it at + and - exposure settings in your **RAW** processing software and blend those in your editing software. All image viewing is a compromise because digital images have a greater brightness range than any monitor or print material available. The **Histogram** is very useful for assessing the dynamic range of an image. An ideal image would show a histogram looking like a hill, starting at the bottom left and right of the 'gram and rising to the hilltop towards the middle. If it starts up the sides on either or both ends, those ends, shadow on the left, highlight on the right, are out of range of the sensor and you will have areas of plain black or white without detail in your picture. If the 'gram starts high on the left, your pix is underexposed and some + exposure compensation will move the hill over to the right for a better exposure. If the high start is on the right, you are losing highlight detail and some - exposure compensation will bring in detail in the whites. That is a pretty simplified explanation of a complex subject! In general, the G9 will choose the

best overall exposure. Where it cannot, **Exposure Compensation** is the first port of call, followed by **HDR**.

Multi Exp

This enables you to fire the shutter up to 4 times on one frame, combining the exposures. After setting the options below, you must initiate the multiple exposure from **Start**, the top item on the menu before pressing the shutter button. After the first shot a **Next/ Retake/ Exit** Dialog pops up giving you some control over the sequence as it progresses. If you set **Overlay** to **Off** in **JPG** or **RAW** quality, the first shot you make after pressing **Start** is the exposure onto which the subsequent ones will be layered. **On** cannot be used in **JPG** quality! Set **On** in **RAW** and you must select the image on which the subsequent ones will be layered from one previously taken one on your **SD card**. When you press **Start**, you will be taken to the previous images to make your choice of starting image. **Note:** You can only choose a **RAW** image.

Auto Gain

For most uses, **Auto Gain** is best left on. With it off you will have to set the exposure of each shot yourself which will involve a lot of experimentation. On the other hand, it could, with care, produce a result exactly to your liking. Play with this facility to see if you find it useful. Lots of fun experimenting with this and you can get some unexpected results!

Time Stamp Rec

This will print the date and time of your picture on the bottom left of every frame and movie. It sets it for both movie and stills at once. It can't be deleted

afterwards so use with care. You can't stamp **RAW** files or **6K/4K Photo** files. This information is available to you in the **EXIF** information written to - but not on - every file, of course.

Motion Picture Menu

Note: although **UHD** is often lumped in with **4K**, strictly speaking it is quite different. **4K** is primarily a cinema format. Its aspect ratio is **1.9:1** as opposed to **UHD**'s **16:9**. Its pixel dimensions are 4196x2160. Surprisingly for a company that produces **4k** professional equipment it nevertheless calls **UHD 4K** so that is what I will do.

Rec Format

AVCHD

This was originally a format for Panasonic and Sony camcorders. It is intended for playback on TVs and Blu-Ray players which can use a limited range of formats, one of which is **AVCHD**. **AVCHD** cannot be used for **4K** shooting. You are extremely unlikely to need it.

MP4

This has become a de facto standard. It is the native format for YouTube. I use MP4 for my Micro Four Thirds Channel on YouTube. It can be played back on just about every device and is easily edited, even on a mobile phone. It uses a compression standard known as H.264 which is highly versatile and gives good quality results with relatively small file sizes.

MP4 HEVC

HEVC stands for High Efficiency Video Coding. It is the next development step from the previously mentioned H.264 compression and is capable of producing video files at half the size of its H.264 antecedent. In the G9's implementation it is available only for HDR (High Dynamic Range) 4K shooting.

You will need to check if your TV or viewing device supports HDR before using this. Most at the moment do not support it, though many phones do. The AAC part stands for Advanced Audio Coding which is a lossy compression like MP3 but capable of giving higher audio quality for a given file size. It is less of a world wide standard than MP3, however.

MOV

This started out with Apple products but is now almost as common and universal as MP4. Any device that can use MP4 will almost certainly be happy with MOV as well. There is no quality difference between the two formats since they use the same compression methods. Which to use? It doesn't really matter. Video editing software will handle both seamlessly and you can mix clips as well. **Note:** MOV does offer more choices than MP4 because it allows for 10bit shooting as well as the normal 8bit. You can't play back 10bit video on most TVs and tablets. It is intended for high quality editing. You can do much more aggressive editing of colour with 10 bit, for example, so that a plain blue sky that would would look banded if darkened might remain smooth with 10 bit. For viewing, you are unlikely to be able to see any difference in image quality even if you do have a 10 bit monitor or TV.

Rec Quality

For stills photographers, video, with its wealth of acronyms and dense terminology can seem more like a black art than photography. Here is an explanation of the main terms used by the G9. If you think these are complex, take a look at the GH5S! **Note:** thankfully for stills people, the G9 has stripped out the harder

choices available on the G9 so you will select your video on size and frame rate. Also, while few people have equipment capable of showing **4k** material, it should be remembered that just as with stills, the more pixels you capture, the more scope you have for cropping in post processing.

- **Image Sensor Output** - **60p**, **25p**, **24p** simply means the number of frames shot for every second of video. **60p** and **30p** are for use in regions of the world where the TV standard is **NTSC**, primarily the Americas, north and south. **50p** and **25p** are **PAL** and mainly for Europe and parts of Asia. They differ because of the different electrical mains frequencies used, 60Hz as opposed to 50Hz, which can cause flickering.

- **F**rames **P**er **S**econd -in theory, the more frames shot per second, the smoother will be any movement in the video. However **30p** and **25p** are the accepted standards and that is what devices an software are designed to use. **60p** and **50p** will be played back as half speed slow motion unless you have a device or software which can adjust the frame rate. Again, since you bought a stills camera, you will most likely want to use **30p** or **25p** to avoid complication. **24**fps is the cinema standard. Enthusiasts consider the motion it produces more 'filmic'.

- **420/8bit/LongGOP and 422/10bit/LongGOP** - this refers to the chroma sub key sampling, colour bit depth and

compression method respectively. 10bit or 8bit? Since the vast majority of monitors are 8bit, 10 bit generally offers no advantage. If you are a stickler for quality and do a lot of editing on your videos, then 10bit may be worthwhile.

• **LPCM/ AAC** - **L**inear **P**ulse **C**ode **M**odulation/ **A**dvanced **A**udio **C**odec are types of sound encoding. **AAC** is a compressed format, **LPCM** uncompressed and thereof better quality but with a bigger file size. Unless you use a high quality external mic you are unlikely to be able to hear any difference. If you like to edit/ tweak the audio in post processing, **LPCM** will be better.

• **Mbps** - **M**ega **b**its **P**er **s**econd. This is the main arbiter of video quality, the higher the better. The G9 doesn't give you a choice of bit rates so it only varies according to the format. Of course, if 60p has twice the bit rate of 30p, it doesn't imply better quality but simply reflects the fact that it is writing twice as much data per second.

• **HLG** - Hybrid Log Gamma. It's a method of encoding both HDR, (High Dynamic Range) video and normal video into one, developed by the BBC. Facebook, iPlayer and YouTube understand it but unless you know exactly why you want to use it, it is probably best left.

AFS/AFF

This is the same as in the Rec menu. It controls the action of the **AFS/AFF** single focus setting of the **Focus Mode** lever on the back of the camera.

AFS

When you half press the shutter button focus is set and pressing the button fully in starts the video with this focus point set. When videoing the camera will re-focus each time you half press the shutter release.

AFF

When you half press the shutter button focus is set and pressing the button fully in starts the video with this focus point set. However, if you half press the shutter while videoing and keep it half pressed, the camera will correct the focus point automatically if the subject moves. This differs from **AFC** (continuous autofocus) in that **AFC** is suitable for predictably moving subjects and will attempt to keep focus by calculating the subject's position. This is potentially much smoother in video than **AFF**. My favourite setting for keeping tabs on a moving subject when videoing is to set the **AF Mode** to **Tracking** and have the camera track their face.

Continuous AF

Set to **Mode 1,** the camera continually focuses only while actually recording. **Set to Mode 2** it continually focuses recording or not. Obviously this will use more battery power. If focus drifts from where you want it a half press on the shutter will readjust the focus point. This setting overrides **AFS/AFF/AFC** on the focus mode lever. Set **Continuous AF** to **Off** and the camera will focus when you start the video and not change. If

you set the Focus Mode Lever to **MF** and **Continuous AF** to **OFF**, you will have fully manual focusing, the preferred method for professionals. **Note:** Micro Four Thirds zoom lenses are not parfocal. That is to say, if you focus on a subject and then change the zoom length, it will not stay in focus. Some lenses do not go off focus as far as others but they will all go off focus. Refocusing combined with the zooming does not make for professional looking video so is better avoided or edited out in PP.

Photo Style

Has the same options as it does in stills. It gives you a series of preset colour values other than the **Standard** neutral. **Vivid** is self explanatory **Natural** gives less vivid than standard colours . The 'soft' in the handbook refers to the colours, not the sharpness. **Monochrome** is obvious. **L.Monochrome** is a low key, moody monochrome. If you are feeling depressed, help others feel the same way when they look at your pictures. Great for landscapes. **Scenery** is bluer skies and greener greens. **Portrait** warms the skin tones. **Custom** lets you set a style from scratch. **Cinelike D** attempts to gives a film like dynamic range so that highlights and shadows retain detail and the video appears quite flat. **Cinelike D** with **Contrast** and **Sharpness** at -5 seems to be a popular choice. This provides a good starting point, retaining detail and enabling you to enhance or manipulate your colours as you wish. If you are shooting two scenes under different lighting but want to match the colours as nearly as possible, for example, this is the setting to use. **Cinelike V**attempts to give a film like contrast

range and is a good choice for everyday shooting without post processing. **Hybrid Log Gamma** is a specific form of High Dynamic Range (HDR) image capture which can extend the range of tones displayed on a compatible display. Viewed on a display not designed for it, the image is unacceptably flat and grey. **Note:** the **Hybrid Log Gamma** setting only appears when **Creative Movie** mode is selected.

Filter Settings

These are the same as the settings in the **Rec Menu**. **Simultaneous Record w/o Filter** is disabled in movie modes for obvious reasons.

Luminance Level

This is a highly specialist video setting. It doesn't alter your recorded image in any way, only the way it will be treated by post processing software. If you are going to be taking stills from your video, 0-255 is best, as programs like Photoshop are suited to it Otherwise, the default is 16-255 and I can see no reason to change it.

Metering Mode

The same as for stills in the **Rec** menu.

Highlight Shadow

The same as for stills in the **Rec** menu.

i.Dynamic

The same as for stills in the **Rec** menu.

i.Resolution

The same as for stills in the **Rec** menu.

ISO Sensitivity (video)

Sets the **ISO** for video, it is set separately for stills. It sets the lowest and highest settings the G9 will use when set to **ISO Auto**.

Shading Comp

If the lens you are using shows noticeable darkening (vignetting) in the corners, this will correct it. It does impose a processing overhead so leave it off when not needed. In reality there are no native Micro Four Thirds lenses that vignette to the point where they need correction. Micro Four Thirds video shooters often like to experiment with vintage lenses or unconventional ones like CCTV designs. These will often vignette and that is where **Shading Comp** shows its worth.

Diffraction Compensation

When a Micro Four Thirds lens is stopped down beyond f/8, diffraction, a form of blurring takes place. It is an optical phenomenon, not a fault. **Diffraction Compensation** sharpens the image up again. This is more often needed in video than stills, since with the lower shutter speeds used in video, the lens is often stopped down more than it would be in stills. The best way to deal with this is to use Neutral Density filters to cut down the light intake. A side effect of **Diffraction Compensation** can be more noise in the corrected areas of the image. **Auto** is a good choice.

Stabilizer

These settings are the same as for stills, though two of them are video specific.

E-Stabilization(Video)

. This works by cropping the image on the sensor a little, leaving a band of unseen pixels all around the image. The visible part of the image can then be moved around to compensate for movement of the camera. It s particularly well suited to correcting jittery camera movement of the type you get when shooting while walking. Since it crops in on the sensor, the angle of view for any given lens is narrowed a little. **Note:** If you are shooting for **FHD** output, shooting in **4K** gives you enormous scope for correcting camera movement in PP.

I.S. Lock (Video)

steadies the camera to the extent that sequences can look like they were shot on a tripod. It works less well with telephoto lenses. For it to work you must hold the camera in a fixed position. If you want to re-frame or zoom or move, you need to turn the **I.S.Lock** off while you do it. When it is in use, a hand icon will appear on screen to remind you not to move. Provided you accept the limitations, this is stunning facility to have for improving your video.

Flkr Decrease

This doesn't work when the mode dial is set to **Creative Movie** but does when you press the red movie button. If your video is showing flicker or striping, as you get when videoing a TV screen for example, **Flkr Decrease** allows you to choose a set shutter speed from 1/50th to 1/120th to minimize it. You have to find the best speed by trial and error.

Ex. Tele Conv.

This gives the effect increasing the apparent focal length of your lens without loss of image quality. This really is something for nothing. In **FHD** quality, A 25mm f1.4 lens becomes a 67.5mm (135mm in FF terms) video lens but retains its f1.4 light gathering capacity. The 100-400mm Panasonic zoom gives the angle of view of a 270-1080mm. To get such an angle on a 35mm camera you would need a lens of 2000mm, a 40x telephoto. In **4K** the effect is less dramatic but still gives a 1.4x boost. **Note:** Such an extreme telephoto effect, while potentially exciting, is very tricky to utilise due to atmospheric movement and camera shake, even on a sturdy tripod.

Digital Zoom

If you lack a telephoto lens you might want to use it but the quality loss renders it less than useful. **Ex. Tele Conv.** is much more effective.

Picture Mode in Rec.

You can shoot still pictures while shooting a video. This determines whether video or stills are given priority and the size of the still captured. This facility is only available when shooting a video by pressing the red **Rec** button on the top of the camera. While videoing, the still is captured by pressing the shutter button.

This gives video priority. The G9 will record video continuously in whatever setting you have previously

set. No matter what the still quality set, the captured still will be a **JPG** in 16:9 aspect. You can shoot up to 80 **JPG**s per video sequence except with **4K**, where only 20 can be recorded.

This is stills priority. Any still shot while recoding video will be in the quality you have set for stills. However, while you shoot the still no audio will be recorded and the still taken will be inserted in the video in place of video. Video will resume when the shutter button is released. You can do this 20 times in **FHD**, 10 times with **4K**.

Time Stamp Rec

This prints a time and date stamp (based on the G9's clock setting) on the bottom left of the video. **Note:** The time stamp is permanent and cannot be removed other than by cropping.

Mic Level Disp.

Show the **Mic Level** display on screen. Handy when shooting bands, for example, to make sure you are not getting distortion because the sound is too loud. As a rule of thumb, the meter should only momentarily flash red on the very loudest peak sounds. I set it to peak just short of red for safety's sake since it is impossible to remove distortion but practical to increase volume in audio software. In some respects, getting good audio is a more exacting task than good video.

Mic Level Adj.

Adjust the recording level for loud or soft sounds. You have from -12dB to +6dB. As a rule of thumb, start at -6dB and adjust up or down until the red light in the next to last box just illuminates at the loudest point of your recording. If you are recording a guitar, say, have the player play the loudest section of the song and set the level to where that just lights the red boxes. Sound levels can only be found by the suck it and see method.

Mic Level Limiter

If you have set **Mic Level Adj.** too high, this will prevent or limit the sound distortion caused. It is better to get it right from the outset and this setting can lead to loss of sound quality. A good back stop where levels are unpredictable.

Wind Noise Canceller

I leave this **OFF** for indoor shoots and **STANDARD** for outdoor shoots without hearing any unwanted effects. The threshold at which to switch from **STANDARD** to **HIGH** is hard to fix but if I can hear wind noise in my ears, I switch. It applies to the G9's in built stereo microphone. (see below for accessory mic.)

Lens Noise Cut

If you are using a power zoom and find the motor noise intrusive on your soundtrack, this will minimize it.

Special Mic

If you have Panasonic's DMW-MS2 stereo shotgun microphone, this will alter its recording characteristics.

Stereo records over a wide area. **Lens Auto** is very useful in that it limits the recording area to the angle of view of the lens. **Shotgun** makes the mic directional while **S.Shotgun** makes it highly directional. If you feel the need you can set the angle Manually.

Sound Output

If you monitor your audio through headphones you have two methods of listening. **REALTIME** lets you listen to the actual sound as it occurs. It won't necessarily reflect what is being recorded. **REC SOUND** lets you listen to the sound as it will be recorded. If there is overload distortion, you will hear it using this method. Unfortunately, it may lag the live sound you are hearing. Volume can be adjusted via the **Control Dial**

Creative Video Menu

Exposure Mode

Similar to stills. The best auto-exposure mode is shutter priority (**S**) with the shutter speed set to (numerically) double the frame rate. I shoot at 25fps so use 1/50th. It gives a natural looking movement but on a bright day may be too slow a shutter speed to be usable due to overexposure. In that case, either use a higher shutter speed and the hell with it or - better - buy some Neutral Density filters.**M**anual is is the professional choice. It avoids any amateurish flickering as the camera changes the exposure but does mean that as you move the camera a scene can be badly exposed. I use **S** mostly. **A** and **P** are viable choices but will likely choose a high shutter speed in bright light which can give a rather choppy effect to video.

High Speed Video

This enables you to shoot video in slow motion. The **4k** settings aren't very radical, offering around 1/2 speed but in **FHD** you have 150fps and 180fps which give 1/5th and 1/6th speed respectively.

Variable Frame Rate

Note: this only works when **Rec Format** is set to **MOV** and with 8bit colour depth. As you scroll down through the settings in **Rec Quality** it tells you if **VFR** is available. If it is, you can use this setting to shoot from 2fps, ideal for getting that fast moving clouds effect, for example to 180fps slow motion. Slow motion is not available with 4K shooting.

HLG View Assist

If you set your **Photo Style** to **Hybrid Log Gamma** the camera display will look unacceptably flat and grey. It won't look that way when viewed on a compatible monitor or TV but it will be rather off-putting when shooting. This menu item amends the G9's EVF and monitor to display **HLG** footage in a more acceptable form as you shoot and review it. There are two modes and which one is most appropriate depends on your subject. By and large, I find **Mode 2** the more natural.

4K Live Cropping

Another tripod mounted operation. If you are shooting in **FHD**, using this the G9 shoots in 4K though the final output is **FHD**, of course. The extra image size lets you crop and/or reframe the image with no quality loss. This is a really useful effect and can add visual interest to your shots. Video is a moving medium after all. When you watch professional movies, you rarely see a static shot filmed with a static camera. Shooting a house exterior, the camera will start behind a car, say, and then move smoothly from behind the car to reveal the house. **4k live Cropping** gives you a little of that combined with smooth zooming if you want. You can have the transition take 20 or 40 seconds (this can be slowed down or speeded up easily in PP, of course). The effect is intuitive to use. Set the time. You see **Start** in the top left hand corner of the frame. Move the box to your starting position and set the size. **Press Menu/Set** and **End** appears top left. Adjust the zoom and position as you want and press **Menu/Set**.

Now just press the shutter and watch the fun. Provided you are shooting **FHD** this is a great facility to have..

Custom Menu - Exposure

 Exposure

ISO Increments

Set to **1EV**, when you press the **ISO** button on the camera and alter the values with the rear dial, the **ISO** values can be set to 200-400-800 etc. Set to **1/3EV** values can be set to 200-250-320-400 etc, giving a more subtle choice of speeds at the expense of more dial twiddling.

Extended ISO

Set to **Off** the lowest **ISO** you can set is 200 and the highest 25,600. Set to **On** you can set from 100 - 25,600. There is no IQ advantage to the settings below 200 and in fact a slight loss in dynamic range. The main use for this is on a bright day when you wish to use a wide aperture on your lens to limit depth of field and isolate your subject. With the 1/32,000th high speed available with the **ESHTR** shutter, **Extended ISO** is not really necessary. Even on a very bright day with an exposure of 1/500th @ f/8 at 100ISO, a shutter speed with the G9's mechanical Shutter maximum 1/8000th will enable you to set the lens to f/2. At the Electronic Shutter's 1/32000th that becomes f/1.4! **Note:** when shooting video, the highest **ISO** is 12,800.

Exposure Offset Adjust.

While exposure is often thought of as being correct or incorrect, the reality is that correct exposure is, within bounds, subjective. If you find that in any given

Metering Mode the results are consistently too light or too dark for your taste, you can make an overall correction here.

Exposure Comp. Reset

Set to **On**, any **Exposure Compensation** you have set will be reset to 0 if the camera recording mode is changed, from **A** to **M**, say or from stills to video and vice versa. It is also reset to 0 if the G9 is switched off. I recommend leaving this setting **On**. It is very easy to forget you have an **Exposure Compensation** set when you switch off the camera and when you start the camera up again on an entirely different subject wonder why it is over or underexposed. On the other hand, if you like lighter or darker results than the G9's meter gives, you can set a compensation and leave it on all the time. **Note:** The G9 has a good dynamic range and if you shoot RAW, you have an entirely usable couple of stops exposure leeway either way. This means that exposure can be tweaked to your exact taste in post processing. A useful exploitation of that leeway is in (say) Lightroom where you can make a copy of your original at -1 stop and + I stop and combine them into an **HDR** image.

Custom Menu - Focus/ Release Shutter

 Focus/ Release Shutter

AF/AE Lock

In the centre of the **Focus Mode** lever sits the **AF/AE Lock** button. Most photographers use a half press on the shutter to set exposure and focus This button offers an alternative so that these actions can be performed explicitly when you press this button. An example of the use of this would be photographing skaters going round an an ice rink. You obviously want to expose for detail in the skaters. You could use **Spot Metering** but in many shots the spot metering area will be centred on the ice and give a false reading. So, set the **AF/AE Lock** button to **AE Lock**. Set the **Metering Mode** to spot and take a reading by carefully lining the spot up on a skater and pressing the **AF/AE Lock** button. Until you press the button again, exposure is locked. You can now shoot away fully confidant that your skaters are correctly exposed wherever they are in the frame.

AE Lock

locks the exposure when the button is pressed. You will see [AEL] displayed to remind you that it is locked.

AF Lock

The camera focuses where it is pointed and locks focus there. No matter where you point it the focus will not

alter until you press the button again. The exposure, however, continues to change in reaction to the scene in front of it. [AFL] is displayed. Note that if you have **Shutter AF** (2 below) **ON** and **AF/AE Lock Hold** (1 below) **OFF**, when you press the shutter release it will override **AF Lock** and refocus. To avoid confusion, when I use the **AF/AE Lock Hold** for focusing, I switch off **Shutter AF**. This applies to **AF/AE Lock** as well.

AF/AE Lock

The focus and exposure are set and locked to whatever they are when you press the button. You could point the camera at the sky and press the button. If you then pointed the camera at your foot in the shadow of a tree, it would remain focused at infinity and exposing for the sky

AF-ON

In **AF-S** it does the same as **AF Lock**. When you press the button, the camera focuses. It stays where focused until you press it again. The purpose of this is really with **AF-C**.

• **Near** where **AF-ON** will focus anywhere in the frame it finds a likely subject, **AF-ON Near** biases the focus point selection to nearer subjects

• **Far** as you'd expect, this biases focus point selection to more distant subjects

AF-ON enables the sport and wild life photographers' favourite technique, Back Button Focusing. You are photographing a football game and one player makes a run with the ball. All the time you keep the button pressed the camera computes his position and keeps him in sharp focus. He is approaching the goal and

about to take a shot, so you want to switch your attention to the goalkeeper as he makes a dramatic save. You swing the camera to the goalkeeper and it focuses on him. But there are defenders running into the goal area sometimes blocking your view of the goalkeeper and the camera will keep transferring focus to them. Your goalie makes his save but your focus is on a defender 10 metres closer to you. Or it would have been, had you not stopped pressing the button when you had focus on the goalkeeper. One you removed your finger from the button, the focusing stopped and remained on the goalkeeper. It takes practise but once mastered gives you real control over continuous focusing. Again, turn off **Shutter AF** to use this otherwise when you press the shutter your chosen focus position will be overridden. You might like to turn on **Half Press Release** too. It makes the shutter release action feel much more responsive.

AF/AE Lock Hold

Set **OFF**, when you press the button the AF and/or AE position/setting are frozen and held so long as you keep the button pushed. Set **ON**, when you press the button the settings are frozen and will stay that way until you press the button again.

Shutter AF

Controls whether a half press of the shutter release causes the camera to focus.

On

When you press the shutter release half way, the camera will focus.

Off

The shutter release simply fires the shutter

Half Press Release

Controls the action of the shutter release button.

Off

The shutter release has a two stage action, rather like the trigger of a gun. Press the release and there is a detente half way. Press a bit harder and the shutter fires. If you have **Shutter AF** set **ON** then **Half Press Release** gives you a definite 'switch' feeling for focusing at the detente.

On

The shutter fires in one smooth action. It has the feel of a hair trigger about it. Great for sports and action, it makes the camera feel very responsive. It can feel a bit uncertain where focusing is concerned. However, set the **AF/AE Lock** to **AF-ON** and **Shutter AF** to **OFF** and the focusing to **AF-C** and you have a beautifully responsive sports camera. Keep the focusing active by keeping the **AF/AE Lock** button pushed but when someone steps in front of you, let it go. Instead of focusing on them, it remains focused on your subject. When the view clears, press the button and focus continues from where it left off.

Quick AF

ON

when your camera is being held steady it assumes you will take a picture and adjusts focus so that when you do press the shutter it should be a bit quicker. It's a bit haphazard because if you have the camera in your hand at your side it will focus on whatever is next to

you. It can be an aid to fast target acquisition but as often as not it gives the camera more focusing work to do.

Eye Sensor AF
ON
When you put your eye to the viewfinder the camera focuses. Can save time.

Pinpoint AF Setting
Pinpoint AF Time

If You have the **AF Mode** set to Pinpoint on half pressing the shutter release a magnified view of the focus area appears in the viewfinder for a set period before the viewfinder reverts to its normal view. This period can be Short, Mid, or Long.
Pinpoint AF Display
The magnified view can either appear **FULL** screen or a **PIP** (Picture In Picture) - in a window

AF-Point Scope Setting
This adds a layer of precision to the **AF Point** positioning. It will only work if you have a **Fn Button** set to **SCP AF-Point Scope**. By default it is set to **Fn4** on the front of the camera body. When you press **Fn4**, the centre of the image area is enlarged and the focus point is set temporarily to **1-Area** with a very small focusing box. When you half press the shutter the focus is set to that small area, giving great precision. You can control whether the entire screen is filled with the magnified area or whether it shows as a window in the centre of the area with **PIP Display**. Keep

Enlarged Display controls whether the enlarged area shows only while you keep the **Fn** pressed or whether you press the button to invoke it and again to dismiss it. Very handy for hand held close up work, an insect in a flower, for example.

AF Assist Lamp

Switched **ON**, in low light where the camera might have difficulty establishing focus, a surprisingly bright red light comes on just long enough for the camera to lock on. Although the G9 will focus in absurdly low light, it does have its limits.

Focus/Release Priority

Which is more important to you? That you can always take a picture, even if it might be fuzzy? Or do you feel it isn't worth taking if it is going to be out of focus? Here's where you express your priority.

AFS/AFF

In single focus: **FOCUS** If the picture will be out of focus, the camera will not release the shutter

BALANCE

Juggles the taking of pictures between focusing and release timing. This works well. If the picture would be slightly out of focus, the G9 will delay the shutter fractionally until the subject is in focus.

RELEASE

The camera will take the picture regardless of whether it will be in focus or not. **Note:** so fast is the G9's single shot focusing that most of the time it will be hard to tell the difference between these settings.

AFC

The choices same as above but for **Continuous AF** so that it can be set separately. For sequence shooting **BALANCE** makes sense since **Continuous-AF** is less incisive than **Single-AF** and it would be a shame to miss a great sports shot because it was going to be slightly off focus.

Focus Switching for Vert/Hor

Operates when the **AF Area**, is set to **1-Area** or **Pinpoint**. With this set **Off**, when you turn the camera from landscape to portrait orientation or vice versa, the position of the **AF Area** stays put on the screen. With this **On**, wherever you last focused in either orientation is recalled. If the camera's metering is set to **Spot**, metering will follow the **AF Area**. So, if you are making a portrait and focus in upright orientation on the sitter's eyes and then turn the camera to landscape orientation and focus again on the eyes, as you move between the two position, the **AF Area** will move to the appropriate area of the screen as you do it.

Loop Movement Focus Frame

When the focus area frame is moved around screen it used to stop at the edges. With this **On** when it reaches the edge of the screen it will re-enter on the opposite side.

AF Area Display

This is a very useful focusing upgrade for those using the G9's **225-area** or **Custom Multi** autofocus modes. Previously, while shooting, the G9 would show you green boxes to indicate the area on which the camera was actually focusing. So if using a custom central

grid of 9x9 boxes on an approaching cyclist,if the G9 selected and thus focused only on the one square over his face, you would see just that box flash green when it locked focus. With **AF Area Display On**, you would see the 9x9 grid boxes outlined in grey with the one in action flashing green. It doesn't sound much but it enables you to see at all times the focusing area that will be used and thus keep it on the desired area of the subject. The more closely you define the area within which you want to focus, the less calculation the camera it has to make. Processing 225 areas before making a decision takes a lot more calculation than 81. The smaller the area selected the faster and more accurate your focus will be. On the other hand, if the area is too small, with a fast moving subject it may be hard to keep it on the subject. As always with photography, it is all about finding the best compromise.

AF+MF

When you half press the shutter, focus is fixed. With this **On**, while the shutter is half pressed you can adjust focus manually. This also works if you lock the focus via the **AF/AE Lock** button.

MF Assist

When you have set the focusing to manual or **AF+MF** above) set to on - for macro work, for example, this will sense when you are turning the lens focus ring and magnify a relevant section of the screen. When you stop focusing the screen reverts to normal.

When you turn the focusing ring on the lens or press the **Fn3** Button on the back of the camera, the focusing area will enlarge and magnify the target.

Focusing area will enlarge only when you

turn the Focus Ring on the lens. Focusing area will enlarge only when you press the left Cursor Button on the back of the camera **OFF** You focus on the normal size image only, no enlargement.

MF Assist Display

When the magnified section of the image appears as a result of manual focusing, choose whether it should take up the whole screen or appear in a window (**PIP**).

Custom Menu - Operation

 Operation

Fn Button Set

This enables you to assign functions of your choice to the G9's 19 physical and virtual **Fn Buttons**. Given the **Quick Menu**, **My Menu**, the 19 **Fn** buttons and all the dials and wheels the G9 is customizable to a wide range of tasks and tastes. Each button has nearly 70 available assignable functions! The only suggestion I have - and what I do myself - is to note what functions I use most over time and set them piecemeal to the **Fn** buttons. I do this by setting all the **Fn** buttons to **Off** and assigning them one by one as I use the camera and get an idea of the functions to which I need quick access. Apart from this menu setting, if you press and hold any **Fn** button it will bring up its present setting and enable you to change it. You can also bring up the settings with a press on the **Fn** icon on the monitor recording **Info.** screen. Not only are there a comprehensive array of buttons, there is a bewildering array of ways to access them too! Oh yes, and they can be set separately for **Rec Mode** and **Play Mode**. Not only that, button assignments are saved with **Custom Settings** and **Save/Restore Camera Settings** so you can assign **Fn1** to **Shutter Type** in **C1** and **Peaking** in C2 and so on! It's a good reason to back up your settings in **Save/Restore Camera Setting**. My personal settings are probably of no interest but I'll list all the 5 **Fn** buttons I use.

1.　　AF Mode

2.　　Quick Menu

3.　　LVF/MON

4.　　Level Gauge

5.　　Guide Line

On the rear dial **Fn**s 16 to 19 I set **16**-Wi-Fi, **17**-Bracket, **18**-Stabilizer and **19**-Silent Mode. These are all subject to frequent change!

Fn Lever Setting

I find this useful for an overall important setting because it is easy to find and easy to feel which position it is in. For that reason I set it to switch between **MSHTR** and **ESHTR**. You use **Function of Fn Lever** to set the overall action and then the **Mode 2 Setting** to set which of those choices available should be invoked by the **..** (up) position.

WB/ISO/Expo. Button

This refers to the 3 buttons on the top of the G9. It gives you a choice of how they operate. Either press a button, make the change and then press the button again to set it or press the button, make the change while pressing it and let the button go.

Q.Menu

This allows you to choose between a **PRESET** or **CUSTOM** version of the **Quick Menu** accessed by pressing **Fn2** by default. As with the **Fn** buttons, there is a bewildering array of choices here. Probably best to go with the **PRESET** at first and amend to taste over the course of time as you learn which parameters you

need to access quickly. My settings will be of little use to you but for the record, Left to right on Page 1, I have **Picture Setting**, **Video Quality**, **Zebra Pattern**, **Quality** and **Ex Tele. Conv.**. I only use one page, firstly because I have run out of things I might want to change and secondly because if I have to scroll to a second page, the **Quick Menu** is no quicker than going to **My Menu**.

Dial Set.
Assign Dial (F/SS)

means front dial

means rear dial. In **A** and **S** modes, both dials alter aperture or shutter speed respectively. In **P** mode both dials shift the combined shutter speed and aperture. This setting really only applies to **M**anual mode and allows you to choose which dial controls which parameter.

Rotation (F/SS)
sets your preferred direction of rotation to change the parameters. You could either set the direction to match a previous camera that you have become used to or to the direction that feels most intuitive.

Control Dial Assignment
This controls what the **Control Dial** does when turned. It doesn't affect its operation as **Cursor** buttons

or, if so assigned, **Fn** Buttons **16-19**. The choices are pretty straightforward mostly duplicating the front or rear control wheels. For video, the **Headphone Volume** would be handy. I use it as immediate access to resizing the **Focus Frame Size**. You need to be careful to avoid jogging unintentionally, though.

Exp Comp

ON

If you like to directly adjust the Exposure Compensation, this assigns it to the front or rear dial. Most useful in **A**, **S** and **P** modes and far more useful than having both dials doing the same thing as they do as standard.

OFF

front and rear dials do the same thing in **A**, **S** and **P** modes. You do have a dedicated button for **Exposure Comp.**, of course so if you are content with that, the next item might suit you.

Dial Operation Switch Setup

This gives the two dials a further set of functions but needs a **Fn** (function) button to be set to **Dial Operation Switch** to access them. When you press the **Dial Operation Switch** entry, a graphic of the front and rear dials appears. Highlight one of them and touch it. You are presented with a menu of a dozen items. Select an action and then do the same for the other dial. Let's say you have assigned **Dial Operation Switch** to **Fn1**, the front dial to **Aspect Ratio** and the rear dial to **Flash Mode**. Now, when you press **Fn1**,turning the front dial will alter the **Aspect Ratio** and turning the rear dial will alter the **Flash Mode**. A half press on the shutter button cancels the temporary

assignment and returns the dials to their normal function. Two things to note here. First, if you set either dial to **Highlight Shadow** both dials are used, the front to to alter highlights and the rear to alter shadows. Secondly, when you assign a **Fn** button to **Dial Operation Switch**, you lose the use of that switch for any other operation, so you are only gaining one function, not two.

Joystick Setting

The joystick was introduced on the GH5 and very welcome it was. While it can be disabled with **Off** I don't think many will want to do that. It can also be used to double up on the **Menu/Set** and **Control Dial** functions or as **Fn** buttons 12-16. It is very fast and versatile as a **Fn** selector but its real functionality is brought out by **D.Focus**. In this mode it makes **Focus Area** control instinctive and responsive. Just move it up, down, left or right to put the **Focus Area** to precisely where you want it. Any moment you want to centre the **AF Area**, just press the joystick. Press it in again and **AF Area** toggles back to the previous focus position. While using the joystick, the **Rear Dial** will alter the **Focus Box** size. With **Fn1** set by default to **AF Mode**, you have **Focus Mode** (AFS, AFC etc), **AF Mode** (225 Area, Pinpoint etc) and **AF Area** position and size all within thumbs reach and - with a little familiarisation - changeable without taking your eye from the **EVF**

Operation Lock Setting

Some camera controls, useful as they might be, are prone to being activated accidentally. This provides a quick way to disable and re-enable the offending

controls. For this to work you must set a **Fn Button** to **Operation Lock**. When you press that **Fn button** it will toggle a lock on any or all of the **Cursor**, **Joystick**, **Touch Screen** or **Dial** operation. **Note:** You must set the **Operation Lock Setting On** in the menu for the **Fn** button to disable it. A common use for this is to temporarily disable the touch screen while using the **EVF** when many photographers find their nose in control of the camera!

Focus Ring Lock

Disables the focus ring. There are many occasions, macro work among them, where manual focus is the easiest way to establish focus precisely where you want it, especially since the G9 can magnify the focus area up to 20x to aid you. It is then only too easy to jog or disturb the ring the ring just enough to lose the critical focus you have obtained. Having determined your focus, set this item **ON** and it will stay where it is.

Video Button

enables or disables the red centre dotted **Video Record** button on the top of the camera. The beauty of this button is that you can press it at any time and video starts shooting at your default settings immediately. Otherwise you have to set **Creative Video** on the mode dial and press the shutter button. The downside of the **Video Record** button is that it can be pressed accidentally. Setting this item to **Off** prevents that. A side effect of disabling it is that you can no longer shoot stills at the same time as video because to do so requires initiating the video recording with this button.

Touch settings

Lots of useful settings here to do with the monitor here.

Touch Screen

Off, the touch screen does not function. You must operate the camera via buttons and dials. Given the superb screen sensitivity and functionality for menu operations, for example, you may not want to disable it entirely.

Touch Tab

On, the tabs for **Fn** Buttons 7 to 11 , touch screen exposure etc appear on the right side of the screen. **Off** You have a clear and uncluttered screen.

Touch AF

AF

when you touch an area of the monitor the camera will focus there.

AF+AE

When you touch an area of the monitor the camera will both focus there and optimise the exposure for that spot..

Touch Pad AF

When your eye is to the viewfinder you can still set the **Focus Area** position by touching the (now blank) monitor screen. This was a a major aid on Panasonic cameras until the advent of the **Joystick**. Worth trying, though. You may prefer it.

EXACT

touch the screen and focus is set at that position.

OFFSET

touch the screen and drag focus to where you want it. I find **Offset** the more intuitive

OFF

Unfortunately, with **Touch Pad AF** enabled it is very easy to accidentally move the focus position with your nose. **Off** solves that problem or you can disable the **Touch Screen** with **Operation Lock Settings**.

Custom Menu - Monitor / Display

Auto Review

If you like to check your image immediately after taking it, this sets the G9 to do so automatically.

Duration Time (photo)

This sets the **Auto Review** for still images only. The image can be held on screen from 1 to 5 seconds before reverting to the live view or, using **HOLD** until you touch the monitor or half press the shutter button. The image will be seen on the monitor or EVF depending on which you are using. Setting an **Auto Review** time does not freeze the camera for that period. If you press the shutter button the view will revert to live and your picture will be taken.

Duration Time (6K/4K PHOTO)

You obviously cannot **Auto Review** a burst of images but **HOLD** compiles the **6K/4K** output into a 'heap' so that you can step through them one by one. The number of the images in the sequence is shown at the top of the screen. **HOLD** is highly useful because usually you will shoot **6K/4K** bursts when you are not certain you will get a particular shot. Confirmation that you have or otherwise is key.

Duration Time (Post Focus)

As **6K/4k** but pertaining to **Post Focus** only.

Playback Operation Priority

sets what happens if you operate the controls while the recorded image is being **Auto Review**ed. Set **On** the buttons behave as if the camera was in **Playback** mode. So, press the **Left Cursor**, for example you will step back through previous images and you can delete

the image immediately with the **Delete** button. **OFF**, the controls behave as if the camera was in **Rec** mode and on pressing any of them the **Auto Review** screen will revert to live view and the button perform its normal **Rec** mode function.

Monochrome Live View

shows the monitor and EVF in black and white. It doesn't affect the image you record which will still be colour. Under some circumstances, manual focusing is facilitated by a mono view. Apparently.

Constant Preview

This takes effect only in manual (**M**) exposure mode. Normally in **M** mode, the G9 will keep the live view screen at a pretty constant brightness level. This is useful in something like a night shot of a dimly lit street so that you can see to compose your picture. On the other hand, **M**anual exposure is often used when the photographer wants to have explicit control over the exposure. If your night shot scene includes street lamps, your picture will look very different if exposed for the area lit by the lamp or for the shadow area in a doorway. If you set **Constant Preview** to **On**, as you open and close the aperture or raise and lower the shutter speed, the actual effect on the image will be seen. Whilst you wouldn't want that for everyday auto shooting where a bright and even live view aids fast composition, for manual you would usually want to see the effect. **Note:** whether **Constant Preview** is on or off,**Exposure Compensation** will show its the effect on screen.

Live View Boost

If you are photographing in a very low lit place and the monitor image is uncomfortably dim, this will boost it. The image will probably appear rather noisy but this won't be reflected in your recorded picture. You can apply it to all exposure modes or restrict it to **Manual** only. This really only comes into its own in very, very dim conditions, under star light, for example. **Mode 1** brightens the screen as much as it can without too drastic an effect on the quality of your viewing. **Mode 2** sacrifices the quality of your viewing in favour of a brighter view.

Peaking

is a focusing aid giving a graphic representation of which areas of your picture are sharply focused by highlighting the edges. It comes into its own in poor lighting when judging focus by eye is difficult. **Set** brings up 3 parameters.

Detect Level

High or **Low** determines the threshold for sharpness. **High** is more precise for more critical focusing. If you are shooting at wide apertures or with long lenses, this is the one to use. **Low** is less critical and therefore faster to work with, good for normal lenses and where the lens is stopped down a bit

Display Color

lets you set any of 5 colours for each of the two levels of **Peaking**. I find blue/ light blue the most effective. **Note:** You may prefer **Peaking** to **Magnify** for focusing when **MF Assist** is switched on. You can use both if you wish. I find **Peaking** ideal for shooting

manual focus video in my dimly lit blues club but magnification better for macro.

Display While AFS

With this **OFF**, **Peaking** works only with **MF**. With it **ON** it works with AFS, (single autofocus), as well.

Histogram

This controls whether you see the **Histogram** when you cycle through the screens via the **DISP.** button on the camera back. A **Histogram** can be used as an exposure aid. It is a sort of graph of the pixels that comprise your image and how many of them there are at each level of brightness. The bottom of the histogram, the X axis, represents the brightness range of the image, with 0, black on the left and 255, white on the right. The Y, vertical axis, represents how many pixels of that tone there are in the image. A normal or average image will contain a range of tones from black to white with a majority in the mid range,

so it will look like a hill in the histogram . If the peak is to the left, there is a preponderance of dark tones in your image, if right, a preponderance of light ones. This might be because your image is mainly composed of light or dark tones but generally it will indicate over or under exposure. Some **Exposure Compensation** will shift the peak towards the centre and balance your exposure for the subject in front of the lens. The **Histogram** is too sophisticated a tool to

go into detail in a book like this. They are most useful
when used in the light of experience since real world
subjects don't conform to any simple rules!

Guide Line

You can add **Guide Lines** to the display to aid
composition or subject placement. If set to
you can move the lines around the screen
using the Cursor Buttons.

Center Marker

A cross is shown in the centre of the screen.
Convenient for re-aligning a scene which you are
shooting over the course of time or centring a zoom -
line up the marker with the subject's eye, say, keep the
marker on the eye and zoom in. One of those little
additions that is more use than you thought it would
be.

Highlight

When viewing/ reviewing your picture, this causes any
any over-exposed light areas, that is areas where there
will be no detail, to flash black and white.

Zebra Pattern

A pattern of diagonal lines indicates saturated
highlight areas of your picture which will contain no
detail. Over-exposed white areas in a picture or video
look particularly unpleasant and harsh. The **Zebra
Pattern** shows you where this problem is occurring
(**Zebra1**) or about to (**Zebra2**)

Set

Allows you to set the zebras to occur at your chosen levels, from 50% to 105% in each case. The defaults of 100% (saturated) and 80% (close to saturation) are well chosen. The remedy to blown highlights is to apply minus exposure compensation. This is where the **Histogram** is useful. You try to adjust the exposure so that the hill-like shape in the Histogram graph does not exceed the borders. In some cases a scene will simply have more contrast than the camera can handle and the decision over what to do can be made only by your own eyes.

Expo.Meter

controls whether you see a graphic of an exposure meter when you turn the front or rear exposure dials. If you set it **ON** but don't see it when you change exposure parameters, press the **Disp.** button until it appears on the detailed information display. It lingers for a few second after changing settings. You have a numeric display of your current exposure on screen whether you have this on or not.

MF Guide

ON

indicator appears when you turn the lens focusing ring and indicates which way to turn the focus ring. From the photographers point of view, turning the ring clockwise focuses closer, anti-clockwise towards infinity (this is by default. The direction can be reversed in **Dial Set** in the **Custom** menu). MFT lenses are 'focus by wire', that is the focusing ring has no physical connection to move the

lens elements back and forth so the ring often has no near or infinity stop points. This can be a little off putting. I find the main use of the **MF Guide** is to establish when the lens has reached its nearest focus point and is thus rendering small objects at the largest size possible in the frame. For landscape, it will establish unequivocally when the lens is focused at infinity. I like it for video, too since my brain seems incapable of learning which way to turn the ring.

LVF/Monitor Disp. Set

This controls where the main shooting information is displayed on the EVF and Monitor respectively. You can either have the info displayed in a black bands outside of the scene or superimposed on the of the

scene itself. Info is displayed in a black band outside of the viewing area. This setting gives a smaller image but keeps the view uncluttered.

Info is displayed on scene itself. This setting maximizes the image area but the info is superimposed on the image itself which you may find distracting. Note: Though the G9's **EVF** is eminently viewable and the largest on any mirrorless camera, if you wear glasses and have difficulty seeing the full width of the screen, it is worth seeing if the smaller image setting can alleviate the problem. **Note:** this menu entry interacts with the **V.Mode** button on the right of the EVF housing. I find I get the best of all worlds by

setting the info to display outside the view area with the **V.Mode** set to its largest view.

Monitor Info. Display

This controls whether or not you see the **Recording Information** screen when you cycle through the screens by pressing the **DISP.** button on the rear of the camera.

On

The Recording Information screen is inserted into the sequence. The recording Information screen is handy because it gives you a summary of all the main settings in use. Not only that, but the display can be live so if you touch the screen on a particular section it will bring up the relevant parameter for alteration. For example, touch the **ISO** sector and the **ISO** setting control will appear. The screen after the Info screen is blank, the monitor turned off. This can save battery life since when you take your eye away from the **LVF**, the monitor will not turn on. A push of the **Disp.** button on the rear of the camera actuates it again.

Off

It is removed from the sequence.

Rec Area

his switches between the your **Aspect Ratio** setting of stills and video. Thus, if you are using **4:3** for stills and **16:9** for video, it will switch between them. The difference between toggling this and just switching between the two **Aspect Ratios** in the **Rec** menu is that if you have the **Ex.Tele Conv.** switched on **Rec Area** reflects the narrower angle recorded by the video compared to the stills.

Remaining Disp.

The **EVF**, **Status LCD** and **Monitor** all show a letter **r** followed by a number. The number can either be the amount of video shooting time left or the number of exposures remaining at your current quality setting. This item allows you to choose which.

Menu Guide

On, when you switch the **Mode Dial** to [image] the **Filter Settings** menu is automatically displayed.

Custom Menu - Lens/ Others

Lens Position Resume

Normally when you turn off the camera, the lens will reset its focus position to infinity. With this **ON,** if you were focused at 1 metre when you turned the camera off, it will come back on focused at 1 metre. If you have a power zoom lens, this will recall the zoom position too.

Power Zoom Lens

This item is only available if you have an electrically operated zoom lens fitted to the G9.

Disp Focal length

When you operate the zoom lever on the lens, a graphical display of the focal length set is shown on screen

Step Zoom

Set to **On**, nudge the zoom lever and instead of sliding through all the zoom range, the camera will stop at predetermined focal lengths. With the 14-42 power zoom, for example, this is 14-18-25-35-42mm. This can feel quicker and more definite in operation

Zoom Resume

When you switch off the camera, by default the zoom will set itself to its minimum setting when switched back on. Set to **On** the lens will resume at the focal length setting when you switched it off.

Zoom Speed

This controls the speed of zooming through the focal length range, Low, Medium or High.

Zoom Ring
You will probably never see this. It only appears for lenses with both a zoom lever, as found on Panasonic's power zoom lenses and a focusing ring. If you have such a lens, set this to off to disable the zoom ring. It can be set separately for Video and Photo

Lens Fn Button Setting
Although Panasonic don't say so, this answers criticism that when using an Olympus lens with a **Fn** button on the barrel, it would not work on a Panasonic body. Panasonic lenses don't have such a button. This answers the criticism fully and you are given an excellent selection of relevant functions. I suspect most photographers will use the default **Focus Stop** setting. With **AFC** in use, if your subject stops, instead of the camera constantly trying to focus, it locks on when you press the button. So, if you are tracking a football player and the referee blocks your view, just press the button to stop focus and release it when the view is clear, avoiding time wasted refocusing on the referee and then back on the player. Conversely, you can also set the lens to only focus when the button is pressed, stopping when released. Both of these are what would be called 'back button focusing' on a DSLR, a technique extensively used by sports photographers. **Note:** if you do you use this focusing method you need to turn off **Shutter AF** in the **Focus/ Release Shutter** section of this menu. You might also like to set **Half Press Release** on to give the G9 an even more hair trigger response than it already does.

Face Recog.

This works only with (**Face Detection**) set in the **AF Mode** menu. **Face Detection** should not be confused with **Face Recog. Face Detection** scans the frame for any face(s) and sets focus and exposure to suit. **Face Recog**. takes that a step further and scans for a registered face. For **Face Recog**. to operate you must first take a passport style photograph of a person and register it using the **Memory** option. Turn on **Face Recog**. and the camera examines your prospective photograph for a registered face, then focuses on and sets the exposure for that person wherever they are in the picture. Take Cinderella and the ugly sisters. If you registered Cinderella's face and then got the girls together for a family group shot, switch on **Face Recog.** and focus and exposure would be set for Cinderella even if the ugly ones made her sit behind them. It won't work in **4K** mode or video.

Memory

Select an empty one of the 6 boxes **Face Recog.** boxes and take a picture of the person you wish to register. You will be told if it has worked. If it hasn't try again, if it has you can fill in the **Name** and **Age** information. Once done, you can go select the image again and edit the info. You can also delete the pic and information. More interesting, you can set a priority for the face so that if it is recognised in any pictures, focus and exposure priority can be given to it. Make sure to register your own face in case you do any selfie group shots!

122

Profile Setup

If you fill in details of your baby or pet here, when you take pictures of them you can have the entered details printed on to pictures of them using **Text Stamp** in the **Playback** menu.

Setup Menu

Online Manual

This stores the URL of the G9's instruction manual which you can copy (manually) to your smartphone for online access. Otherwise, display the QR code and your phone will go to the URL automatically. You can save it to the phone if you wish for handy access.

Cust.Set Mem.

C1/ C2/C2/C3-1/C3-2/C3-3 Saves your current settings to memory for instant recall and use. There are 3 main **Custom** settings and 2 further ones selectable under **C3**. With all the normal **Mode Dial** settings, **A**, **S, P** etc, the camera remembers its settings as they are when you switch off. When you switch on again the settings are as they were left. So, if you were set to **A**perture priority, ISO 400, **Spot** metering mode and then switch off, that is how the camera will be set when you switch it back on. Now set ISO to 200, switch off and back on. A is now set to spot metering mode, ISO 200. It remembers the setting last used. With **Cust.Set Mem.**, if you set the camera to **A**, spot metering mode, ISO 400 and then record that setting to **C1**, every time you set the camera to **C1**, it will return to those settings. If you now alter the ISO to 200 and switch the camera off, on switching back on, it will return to its **C1** setting, **A**, spot metering mode - ISO 400. So, if you have 2 main types of pictures that you take, sport and street, you set the camera to your favoured settings for those subjects. Let's say, **S**hutter Priority, ISO 800 for sports and P (Program) with Auto ISO for street. Record those to **C1** and **C2**

respectively. Now, on your way to the sports event set the camera to **C2**, your street settings. When you arrive at the sports event, set the camera to **C1**. Practically everything is recordable to custom memory. It is one of the treasures of digital cameras. **Note:** In a **Custom** setting set to **A** mode, the aperture set is saved and when you switch on will be restored. In **S** Mode the shutter speed set is saved. In **M** mode the shutter speed and aperture are saved (and will likely need adjusting, of course). In a Custom mode set to **P**, it opens with the exposure set for the current lighting. The basic building block of a **Custom** setting is the Exposure Mode, **M**, **S**, **A**, **P** or **Creative Movie**. Therefore the best way to set a mode is not in the **C** setting itself but in the mode which you wish to employ. Set the camera to, say **A** and go through the menus setting up as you wish. Then go to **Cust.Set Mem** and save it. The state of the monitor is saved to **Custom** settings too, so if when you save a setting, the monitor was set to the **Info** page, that **Custom** setting will always open with the **Info** page. I set the monitor to minimum clutter and save it that way. If you want to set **Cinelike D** or **Cinelike V** to a video setting, you must set it in **Creative Movie** mode on the dial and then save it to your **Custom** setting. **Note(2):** You will notice that if you are in a Custom setting and the camera goes into **Sleep** mode, any change made to the setup will be lost, since after **Sleep** the Custom setting is restored as it was. If you are shooting racing car meeting and have **C1** set for your race settings to use **S**hutter priority you may decide to change that to **A** priority. If the camera goes into sleep mode between

races, when you wake it up it will be back in **S** mode. You can also **Save/Restore Camera Settings**, see later in this menu. Apart from the fact that you can store 10 setups to a card, this differs from **Custom** settings in that it only loads the settings. If you change them during a session, on sleep or switching off, when the camera is powered up again, the changes you made will still be there.

Clock Set

Self explanatory.

Style

You have the usual choice of display modes, 12/24hr and European or American date standards.

World Time

Set up the camera for a **Destination** and whether **Daylight Savings** are applicable in your **Home** and **Destination**

Destination

Set your **Destination** location time zone.

Home

Set your **Home** location time zone.

Travel Date

taking your shiny new G9 on holiday? You can set your travel and return dates in advance and the G9 will apply them to your **EXIF** (Exchangeable Image File Format) info without further intervention. Whether the airline will match your camera's efficiency is another matter!

Travel Setup

Set when you are leaving and when you are returning

Location

Enter the name of the place where you are going. The camera will automatically set that time and location to the **EXIF** of your pictures and back automatically on the return date you have set.

Wi-Fi

This can be used for various tasks on its own and in conjunction with the Bluetooth connection in the next menu item. I find the most useful are **Remote Control** via the **Image App**, sending pictures to my desktop as taken and Geotagging. I don't see much possibility of anyone intercepting my **Wi-Fi** picture transmission and even less of them wanting to keep my pictures if they did, so I don't bother with a password. **Note:** Wi-Fi can eat battery power! You can switch it off at any time by going back to **Wi-Fi** and pressing the 'back' icon on the bottom left of the menu page.

Wi-Fi Function
New Connection
Remote Shooting & View

1. After pressing this, go to your smartphone and open the Wi-Fi connections list (where your router is listed)

2. You will see G9 followed by some random letters and numbers

3. Select this and the phone will connect to the camera. You may see a dialog telling you that 'the internet may not be available'. Dismiss this

4. Start the Image App

5. A dialog box appears on the camera monitor asking you if you wish to connect to the phone. Answer **Yes**

6. The camera will show **Under Remote Control** and you will see the monitor image duplicated on your phone with the camera controls

Playback on TV
Depending on the TV, you can connect directly to it or via your home Wi-Fi network. Setting this up will require the TV instructions.

Send Images While Recording
A useful facility which will send **JPG** or **RAW** images directly to your chosen destination immediately you take them.

Smartphone
The easiest connection is **Direct -> Manual Connection** which uses the same procedure as **Remote Shooting**. When connected, start up the **Image App** and the camera will ask you if you wish to connect. Touch **Yes** and your phone ID comes up on the camera monitor. Touch that and you are presented with the **image send settings**. Touch the **Disp.** button and you can choose to send a **JPG** according to the current camera setting (**Original**) or a smaller size using **Change**. You can also send **MP4**. All in all, it is a lot easier to connect to the Image App as above press the **Playback** icon. This shows you all the images on the G9 and you can select them for copying to the phone.

PC

Normally you'll connect via your network. Your router will have a **WPS** button and the G9 gives you 2 minutes to get to your router and press it. You will be asked to select a device to connect to. Select your PC and then a folder on the PC to which images should be sent. The folders shown will be all of the ones on your PC which set to **Shared**. You will find that setting under file **Properties** -> **Sharing**, accessed by a right click on the folder in File Explorer. I make a folder on my PC called CameraUpload and set that to **Shared**. The G9 will then send pictures as they are taken to that folder, filed under the date of shooting. **Note:** You can connect to your PC manually but this will entail putting in a user name and password which is not catered for very easily in Windows. If you have a network storage drive **NAS** attached to your router, this will show up too and can be convenient since it will be on 24/7 while your PC may not.

Cloud Sync Service

Panasonic operates an online account where you can upload up to 1000 images from your camera. Once you have an ID you can access **Cloud Sync Services** and the **Web Service**. Your images will be stored for 30 days and then deleted. These images can be uploaded directly to YouTube, Facebook, Flickr and a few others or downloaded to your computer if you wish. You can register for the **Lumix Club** in the **Wi-Fi Setup** section of this **Wi-Fi** menu.

Web Service

This will upload via the Lumix Club directly to Facebook, Flickr, YouTube, Twitter etc. You will need

to enter your login details for these sites on the Lumix
Club web pages for this to work.

AV Device

Send to your home theatre. Again, via **Network** or
Direct if your device accepts it. This will have to be
done via your device.

Send Images stored in the Camera

This is the same as **Send Images While Recording**
but you will select the images to send from the SD
Card(s).

Select a Destination from From History

As you make Wi-Fi connections a log of the stored
here. Select one of the connections and the G9 will
connect automatically. If you press **Register to
Favourite**, you can change the connection name to
something memorable like Smartphone and it will be
listed in **Select a Destination from Favorite** for easy
future access. This is also handy if you access Wi-Fi
connections in more than one location.

Wi-Fi setup

Priority of Remote Device If set to the Smartphone
icon, the G9 is entirely controlled from the phone
when under **Remote Control**. If you try to alter the
shooting mode from **A** to **S**, for example the camera
reacts with a rather testy little message reminding you
that it is under remote control. Set to the Camera icon,
it allows you to perform some functions on the camera
itself at the same time restricting what can be done
from the phone. In practise, all the common changes
can be made from the Smartphone priority setting and
this is the logical one to use.

Wi-Fi Password

If you are seriously concerned about someone stealing your images while transferring them via **Wi-Fi** you should make sure this is set **On** before making a connection.

Lumix Club

You can set up, delete or add a **Lumix Club** account here. You can transfer images to social media sites and other web services via **Lumix Club**. Touch **Set Login ID** and you will be given a **Login ID** number. Touch **Password** to set a password of your choice. Now go the **Lumix Club** web site and enter these. You will be presented with several options, among them to transfer images directly to Facebook and other social media sites.

PC Connection
Workgroup

By default on Windows this is WORKGROUP. If you go to Control Panel - System you will see the Workgroup name there. If it is different, set it here.

Device Name

When you see your G9 listed in the available Wi-Fi networks on your smartphone or tablet it will be G9 followed by a series of numbers. You can set any name you like here and that will be the one you see listed. Technically this is the camera's SSID.

Wi-Fi Function Lock

enables you to set a password that must be entered before Wi-Fi will operate.

Network Address

For information only. Displays the Media Access Control (MAC) address of the camera. This is a unique

hardware identifier for the device. The IP address is assigned by the device to which it is connected.

Bluetooth

This is essentially an adjunct to **Wi-Fi** operation. Not all phones support this and it can be tricky to get it working - be persistent because once you have made the connection, it will happen automatically next time. It is a low energy specialized type of Bluetooth which drains the smartphone's battery very little. It can be problematical on some Samsung phones. If so, try switching Airplane mode on and Bluetooth on and off a few times . The main reason for using Bluetooth for me is to write GPS location coordinates to my pictures.

1. Switch Bluetooth on in the camera and **Set** > **Pairing**

2. You will see a 'pairing' dialog box on the camera monitor

3. Start the **Image App** and touch **Bluetooth** on the **Home** screen

4. You will see G9 and some random numbers in the **Camera Enable to be Registered** box that appears. Touch that. The camera is paired

5. You will be told to switch on Wi-Fi to complete the registration. Do so.

6. Select the G9###### from the Wi-Fi connections list on the phone.

7. The G9 will be paired and registered permanently on your phone

8. In future, when you start the **Image App** and turn on **Bluetooth** on the camera, provided it is turned on on the phone, they will automatically connect and **Wi-Fi** will be started up shortly

9. Given the slight flakiness of the Bluetooth operation with some phones, it makes sense to set the connected setting to a **Custom.Set Mem**

Remote Wakeup

The procedure with this is to set it **On** and then turn the G9's On/Off switch to **Off** If you now start up the **Image App**, go to the home page (the orange house icon) and touch **Remote operation** the G9 will start up and connect to the **Image App**. Having done what you wanted with the camera, if you go back to the home page, you will see an **Off** icon at the top right. Hit this and conform in the dialog box that appears and the G9 turns **Off**. If you are photographing a bird feeding its chicks in a nest, you will want to set the G9 up close to the nest. When the parent bird goes off to find food, you know the camera will be idle until the bird returns. With **Bluetooth** you can power off and save the battery for that period, very handy given that visiting the camera to change the battery will spook the birds each time.

Returning From Sleep Mode

If the camera goes to sleep while you have a Blutooth connection running, you can set a priority to wake it up from either the remote shutter control or image

transfer and remote operation. Set it to the mode you are using at the time.

Auto Transfer

Enabled, this will transfer images to your smartphone automatically when the G9 is connected to your smartphone. You will see a dialog box, **Connected**, which defaults to a **M**edium size JPG but can be altered if you press the **Disp.** button. You can't send **RAW** or video or pseudo video like **6K/4K** or **Post Focus**. That makes sense because smartphone do not generally have a great deal of storage space and large files can take a long time to send over Wi-Fi.

Location Logging

This is a big improvement on earlier methods of writing GPS information to images which relied on transferring them in bulk after shooting. Enabled, it uses little battery power and effectively makes your smartphone a built in GPS for the camera. You can tell when location logging is in force on the **Info** screen by a prominent GPS and Bluetooth icon. If it is flashing, it means the phone GPS has lost positional information.

Auto Clock Set

Since your smartphone will be getting accurate time signals from the Internet, this will keep the camera up to date and synced with your smartphone.

Wi-Fi Network settings

This enables you to connect conveniently to a Wi-Fi network without leaving the **Bluetooth** menu.

Wireless Connection Lamp

This simply turns the blue wireless indicator light on the camera body on or off.

Beep

Beep Volume

This controls the volume of all the system beeps, focus confirmation, warnings etc. A choice of two loudness levels and Off.

E-Shutter Vol

The **E-Shutter** is almost silent in operation. While that is good in many situations, it can be hard to know when it has fired. Here you set volume for the artificial click sound you favour. Two levels of loudness and Off

E-Shutter Tone

Three tones from dry to wheezy. I'd like to have seen Hasselblad and Leica tones here!

Headphone Volume

When you plug headphones in to the G9 to monitor video sound you can vary the volume here. Rotating the **Control Dial** will do the same thing.

Economy

Sleep Mode

Set this to the minimum that doesn't annoy you. Note that if you are using a **Custom** setting and have altered it, when you wake the camera up by half pressing the shutter release it will have reverted to the **Custom** setting. So, if you are using a **Custom** setting that is set to **4:3 Aspect Ratio** but you have altered it to **16:9** in the **Aspect Ratio** menu, if the camera goes into **Sleep** mode, when you wake it, it will have reverted to **4:3**.

Sleep Mode(Wi-Fi)

set to **On** If the Wi-Fi is active but not connected to anything for 15 minutes, it will automatically turn off. Wi-Fi is a heavy drain on the camera battery so this is a useful precaution.

Auto LVF/Monitor Off

Again, set this to the minimum that doesn't annoy you. The EVF and monitor are big consumers of battery energy so the shorter this setting the better. Touch any button or the monitor to resume normal viewing. This does not reset the **Custom** setting. Using the previous example, if it went off in **16:9**, it will resume in **16:9**

Power Save LVF Shooting

This is an extreme but not too inconvenient power saving ploy. To use it, first make sure the **EVF/Monitor Switch** is set to **Auto** and that the monitor is showing the recording information screen. Now, the camera will go into **Sleep** mode in 3, 5 or 10 seconds as set. The camera wakes up in a second or so with a half push on the shutter button. This has the potential to double the number of shots per battery charge. It drives some people mad, however! Note that if you are using **C**ustom mode and have altered the setting, it will revert to the recorded **C** mode. So, if you are using **Custom 1** which is recorded as Aperture Priority mode, f/4, ISO200 and change the settings to Shutter priory, f/16, ISO1600, when the camera is woken up from **Power Save LVF Shooting** it will be back at Aperture Priority, f/4, ISO200. Loading a setting from **Save/Restore Camera Settings** will avoid that so that the G9 will come back with the settings with which it turned off.

Monitor Display Speed

60fps gives smoother viewing, use **30**fps to reduce battery consumption a little. I opt for the smoother viewing.

LVF Display Speed

120fps or **60**fps. I prefer the smoother viewing, especially when panning the camera.

Night Mode

If you find the brightness of the **EVF** or **Monitor** is dazzling or affecting your perception of the scene you when photographing at night or in very dim surroundings, this applies a red tint reducing the contrast between view and reality. You can set the **EVF** or **Monitor** separately. This mode is more effective than it at first seems.

Monitor Display

This can adjust **Brightness**, **Contrast** and **Saturation**, **Red Tint** and **Blue Tint** of the monitor and viewfinder. Note: There is wizardry afoot here! If you view the menu through the **EVF**, you will see **Viewfinder**. If you view the menu on the monitor, you will see **Monitor Display**. The alterations you make will be stored and applied to the EVF or Monitor separately. I find the default neutral settings to my taste and leave this alone.

Monitor Luminance

sets the brightness of the monitor with reference to the

ambient light. Set to ![icon], brightness is adjusted

automatically. **Mode 1** is brighter than standard, **Mode 2** is standard brightness and **Mode 3** darker than standard. If you are OK with **Mode 3** it will save a bit of battery power but I find **A**uto brightness works best for me.

Status-LCD Backlight

Being an LCD, the Status panel needs no backlight in daylight. To the extent that it makes use of the monitor necessary only for reviewing pix, it is a battery saver as well as an at a glance guide to the G9's main shooting parameters. At night, the LCD can't be seen, of course, so a clockwise twist on the camera's **On/Off** switch switches on a backlight for a few seconds. There is a choice of two levels.

Eye Sensor

Sensitivity

When **LVF/ Monitor Switch** is set to auto, this controls how easily it switches between Monitor and EVF. Experience will tell you which is best for you but I find **LOW** minimizes unwanted switching when using the monitor and your sleeve goes near the EVF mounted sensor. It can be very irritating!

LVF/Monitor Switch

The G9 will switch automatically between EVF and Monitor as move your eye to and from the EVF. However, when you have the camera on a tripod and the **Sensitivity** set to **Low** your arm or hand can come close enough to the switching sensor to make it switch when you don't want it to. This item enables you to explicitly set the viewing to EVF or Monitor. **Fn5** is set to toggle between the auto/Monitor/EVF settings

by default. If you alter the setting there, it changes this menu item at the same time. If you find you use **Auto** all the time, you can re-assign the **Fn5** button to something else, of course.

Sensitivity

When **LVF/ Monitor Switch** is set to auto, this controls how easily it switches between Monitor and EVF. Experience will tell you which is best for you but I find **LOW** minimizes unwanted switching when using the monitor and your sleeve goes near the EVF mounted sensor. It can be very irritating!

LVF/Monitor Switch

The G9 will switch automatically between EVF and Monitor as move your eye to and from the EVF. However, when you have the camera on a tripod and the **Sensitivity** set to **Low** your arm or hand can come close enough to the switching sensor to make it switch when you don't want it to. This item enables you to explicitly set the viewing to EVF or Monitor. **Fn5** is set to toggle between the auto/Monitor/EVF settings by default. If you alter the setting there, it changes this menu item at the same time. If you find you use **Auto** all the time, you can re-assign the **Fn5** button to something else, of course.

Battery Use Priority

If you have Panasonic's accessory battery grip fitted, this determines which battery is used first. It is probably more convenient to use the grip battery first and treat the body battery as a backup, since if the body battery is used first you have to remove the grip to change it.

USB Mode

Sets the function of the USB port.

Select on connection

This asks you which connection you want, **USB** or **Pictbridge**

Pictbridge(PTP)

Set to this if you want to connect to a **Pictbridge** printer to print directly from the camera.

PC

The G9 appears as an external drive when connected to a PC or Mac. You can drag and drop files to your PC but you cannot delete the files from the camera when you are finished. Deletion must be done in camera.

USB Power Supply

When the G9 is connected to a PC for file transfer, it will normally take power from the USB3 cable supplied. If you are using a laptop with limited battery power, say, you might prefer power the G9 from its own battery. In which case, switch this **Off**. **Note:** if you are not using the USB3 file transfer cable but the supplied power cable (it's just a mini USB plug, actually) thus item has no effect. If you plug the G9 in to charge it, it will charge.

TV Connection

HDMI Mode (Play)

When connecting to your TV with the HDMI cable, sets the output resolution compatible with your TV. You may need to look at the manual for your TV if you have a problem with this. Normally, set this to

Auto and the TV will tell the G9 its output resolution without your intervention

HDMI Mode (Rec)

you can have the shooting information displayed on the external screen while monitoring or not.

Viera Link

If you have a **Viera** compatible TV and connect the camera to it with an **HDMI** cable, you can control the camera with the TV's remote control.

Language

Choose your language from here.

Version Disp.

Panasonic and Olympus update the firmware, the code built in to their lenses and cameras, from time to time to take into account user requests, more efficient use of the hardware capabilities and so on. **Body Firmware** and **Lens Firmware** versions are displayed. If you visit the relevant maker's web site, you will be able to see if there is a more recent version of the firmware available. You should keep firmware up to date to get the best from your equipment. You can update Olympus lens firmware on a Panasonic body and Panasonic lens firmware on an Olympus body. If you have other Micro Four Thirds system peripherals attached it will display their firmware version too.

Activate

Panasonic offers a paid for upgrade to the G9 which will enable **V-Log L** recording and the display of a **Waveform Monitor**. V-Log L is a way of maximizing the dynamic range of the camera for

maximum flexibility in color grading and post processing of your video. A **Waveform Monitor** is a specialized form of **Histogram**. If you want to make this upgrade, you need an **Activation Code** bought from Panasonic. This is where you enter it.

Folder/File Settings

In general the default file and folder naming of the G9 works well and there is little need to change it. The folders start at 100_PANA and each one will hold 999 image files. The 1000th image will cause a new folder to be created, 101PANA and so on. You could create a folder called MYFOL if you prefer. The prefix number will still increment so if if the camera was at 102PANA, your folder will be 103MYFOL. The R number on the right is the number of files the folder will accept. An empty folder may not show 999 files - that is because it starts from the last file number even if it has been deleted. Thus, if you shoot 400 images in 102_PANA and then delete them, the next image file number will be ****401 and the capacity will be R - presumably standing for Recording(?) - 599. You cannot reset the folder numbers to 100*****. They will increment to *****999 and then reset. You can reset the file numbering (see **No. Reset**). Image file names will always start with an _ (underscore) or a **P**. The underscore denotes an **Adobe RGB** file colour space file, the **P** denotes a **sRGB** file. **Adobe RGB** has a wider colour gamut but should only be used for professional purposes where a client requests it. It does not enlarge the range of the sensor, merely writes more colours in the available range to give professional users more colours to play with. Used with normal

display devices, it can give a flat, compressed appearance to images. The professional user will output **Adobe RGB** to **sRGB** for general use. **sRGB** is the de facto standard because it encompasses the colour range of modern monitors, TVs, smartphones etc.

Select Folder (SD1)

If you have created a folder in the **Slot 1** SD Card, this tells the G9 to save files to it.

Select Folder (SD2)

As for the previous entry but Slot 2, of course.

Create a new folder

You can create a new folder with the 5 letters/ numbers of your choice here. **Create Folder** tells you the folder name protocol that will be used. Use change to redefine it.

File Name Setting

Lets you choose the file name protocol. If you were shooting for a client named Jim, you could change the name settings to PJIM**** for easy identification. **Folder Number Link** sets the G9 to use the 3 digit folder number as part of the file name, so if the folder is 103MYFOL, the image file names in that folder will be P103****.

Double Slot Function

For the greatest flexibility it is best to use cards with the same specs, for best performance all round, that will be UHS-3 cards. I prefer to use the same make as well.

Recording Method

This treats the cards in the 2 slots as one big card. It records everything to Slot 1 and when that is full continues to record seamlessly to Slot 2. For video, when one slot is full and recording passes to the other one, you can change the full one while continuing to record.

This saves everything to Slot 1 and backs it up to Slot 2. Each card will contain the same material. It guards against the failure of an SD card.

This treats each card as a separate entity. When selected, you are presented with a choice of destinations for the G9's shooting possibilities. If you use Lightroom, it is handy to set **JPG** and **RAW** to different cards as LR makes a bit of a mess of **RAW+JPG** imports. I use the JPGs for any immediate use while only importing the **RAW** files. This keep them nicely separate.

Save/Restore Camera Settings

This is an alternative to the 5 **C**ustom settings. You can store and restore 10 settings and the all settings can be backed up to your computer and copied over to

other G9s - if you buy such cameras in batches! Apart from the backup facility, the best attribute of using this to load a configuration to the G9 is that unlike **Custom** settings, when the camera goes into Sleep mode, it retains any changes you have made to the loaded configuration. Lets say you have **Custom 1** set to **ISO Auto/ Aspect ratio 1:1** but you later it during shooting to **ISO 200/ Aspect Ratio 4:3**. When the camera goes into **Sleep Mode** after the period you have set in **Economy**, it will reset to its Custom settings of **ISO Auto/ Aspect ratio 1:1**. If you have **Load**ed a **Camera Setting** which uses **ISO Auto/ Aspect Ratio 1:1** and you change it, when the camera wakes from **Sleep** your **ISO 200/ Aspect Ratio 4:3** will still be there. It sounds trivial but it can save a lot of fiddling with the camera! **Note:** The **Camera Settings** files reside on the SD Card in Slot 1. If you change the card they won't be there, of course but remember also that **Format**ing the card will wipe the settings file. The easiest way to back up your settings files is to drag and drop their folder structure over to a suitable place on your PC. The individual settings files are on the G9 in AD_LUMIX/CAMSET. I make a folder called **G9 Settings** on my PC and then drag the entire folder structure over to it. While you can drag the folders over to your PC from the **USB 3** cable connection on the G9, you cannot drag the folders over to the PC since the G9 prevents outside sources from writing to or deleting files. Just put the SD Card in your card reader and copy the complete AD_LUMIX/CAMSET folder to its root. You can, of course, keep as many sets as you wish for different

purposes on your PC and chop and change them at will. Apart from **Load** and **Delete** the only option here is in:

Save

You can give the settings a descriptive name rather then the 8 letter/ number CAMSET## using **Change the file name**.

No.Reset

This resets the File Numbers to start from *****001. It cannot start from the same folder, of course since it may have a previously shot image with that file name. So, it makes a new folder and starts from *****001. If the last image you shot was PG93020.jpg in folder 103MYFOL, after a **No.Reset** you will have a new folder, 104MYFOL and the first file in that will be PG94001.jpg. Remember, the **P** tells you that the **Color Space** is set to **sRGB**. If you want to start everything from scratch, including the folder sequence, first of all **Format** the card, then perform a **No. Reset**. If you say **Yes** to **Reset** File and Folder, you will have a folder 100MYFOL and the image files in it will start at PG90001.

Reset

This gives you, step by step, the option of resetting **Rec**, **Setup**, and **Custom** settings. Mainly handy if you are selling the camera. Resetting used to be a big deal because if you changed your mind after the reset for any reason you had to go through the entire camera trying to recall how it was set. Now, with **Save/Restore Camera Settings** a **Reset** is not final since you can **Load** your camera settings from the files

backed up to your PC. You did back them up, didn't you?

Reset Network Settings

Wi-Fi and **Bluetooth** connections sometimes seem more of a black art than a technical undertaking. When I get in a total mess, I like to just erase all the connection settings and start over. This menu item will do exactly that. For the reset to be completely effective, it is best to have your smartphone **Forget** previous **Wi-Fi** and **Unpair** previous **Bluetooth** connections

Pixel Refresh

I've never come across them myself since I've been using Micro Four Thirds cameras but it is possible that sensor pixels become ineffective and give bright pin pricks of random coloured pixels in your images. **Pixel Refresh** will identify and correct them. It probably does this by comparing them with surrounding pixels and picking a similar tone for the inaccurate one(s). It doesn't sound ideal but one or a few pixels among 20,000,000 doesn't actually matter.

Reset Network Settings

Wi-Fi and **Bluetooth** connections sometimes seem more of a black art than a technical undertaking. When I get in a total mess, I like to just erase all the connection settings and start over. This menu item will do exactly that. For the reset to be completely effective, it is best to have your smartphone **Forget** previous **Wi-Fi** and **Unpair** previous **Bluetooth** connections

Pixel Refresh

I've never come across them myself since I've been using Micro Four Thirds cameras but it is possible that sensor pixels become ineffective and give bright pin pricks of random coloured pixels in your images. **Pixel Refresh** will identify and correct them. It probably does this by comparing them with surrounding pixels and picking a similar tone for the inaccurate one(s). It doesn't sound ideal but one or a few pixels among 20,000,000 doesn't actually matter.

Sensor Cleaning

The sensor is cleaned every time you turn the camera on by a magnetic mechanism shaking the sensor at very high speed. It simply has the effect of dislodging dust. If you see dust on the sensor when changing lenses or in the form of 'dust bunnies' on your images, you can run the **Sensor Cleaning** any time (and as often) as you wish. **Note:** Any dust present is not on the sensor itself but on a protective clear filter in front of it. When you see a dark patch on an image, usually on an even toned part such as a clear blue sky what you are seeing is not the dust but its shadow falling on the sensor. Mostly the camera's **Sensor Cleaning** dislodges it but if it does not, you may need to get it professionally cleaned. You can buy very good cleaning kits of you want to it yourself but you will need to take great not to scratch the filter. Having said that, the filter is tough and soft lint free cloth will never scratch it. How do you get lint free cloth? A thin cotton T-shirt cut up into cloths and washed many times will be lint free. Most dust on a Micro Four Thirds sensor will never be seen since the lenses are

usually used at f/4 or so. That means that when the light arrives at the sensor the shadow of the dust is diffused. If you want to see check for any dust, stop the lens down to f/22 and look at an even toned area of your image. I personally don't go looking for it since I usually shoot at f/4 or wider and it is not a problem. Precautions against gathering dust are: make sure the rear of the lens is clean before fitting it. When you do change lenses, try to hold the camera mouth downwards. The worst stuff to get on the sensor is pollen. It can stick and be impervious to the vibration cleaning of the camera. If it does stick some kind of wet cleaning will be necessary. You can buy suitable fluids as part of a cleaning kit.

Level Gauge Adjust

The **Level Gauge** comes preset. If you find it inaccurate, put the camera on a known level surface or set it level with one of the spirit levels that fits in the flash hot shoe. Press **Adjust** and that will be your new **Level**.

Format

This deletes everything on the SD Card and sets it up to work correctly with the G9. If you buy a new card it is as well to insert it to the camera and format it before use. If you have a problem with an SD card, **Format** is the first thing to try to correct it. It differs from **Delete All** in the **Playback** mode in that it will also delete any settings you have saved under **Save/Restore Setting** as well as all files.

My Menu

I simply include these for the sake of completeness. Your choices will obviously differ from mine.

Shutter Delay

AFS/AFF

Economy

Bluetooth

Center Marker

Auto Review

Peaking

Highlight Shadow

Continuous AF

Time Lapse Video

Stop Motion Video

Self Timer

4k Live Cropping

High Speed Video

Mic. Level Display

Histogram

Format

Save/Restore Camera Settings

Playback Menu

Slide Show

You can choose to set up a show of everything on the camera, still pictures or Video. Whichever option you choose **Setup** appears and you are offered two options

Effect

Set to **Off**, you have a normal slide show where your pictures are simply displayed one after the other. The other options give different panning effects and a different choice of music.

Setup

Duration Sets for how long each picture displays, from 1 to 5 seconds.. Note that this works only when **Off** is selected under **Effect Repeat** Show each picture once and then stop or recycle though them continuously.

Sound

Auto If you have recorded your own sound with the file it will be played. If not, the built in music will be played. **Music** Panasonic's built in music will be played. It changes depending on the Effect chosen **Audio** If you added audio to the file it will be played, otherwise no sound. **Off** Silence as the slides are shown.

Playback Mode

Sets which types of files are displayed when you press the **Playback** button. **Normal Play** shows everything on the card. **6K/4K** bursts and **Post Focus** files are regarded as **Pictures**, not **Video** for playback purposes.

Protect

Select the picture you want to protect and press **Set/Cancel** or the **MENU/Set** button. A key symbol appears below the word Protect on the top left of the screen.

Multi

As above but you select multiple pictures for protection. While **Protect** helps prevent accidental deletion, it does NOT protect from deletion by the **Format** item on the **Setup** Menu. Neither does it protect your file once the SD card is removed from the camera.

Cancel

Removes all protection.

Rating

You can give your pictures Star rating from 1 to 5. Press **Single** or **Multi** and the **Set** on screen or the **Menu/Set** button and the Stars appear. You will see the rating of each image on screen when set. In **Single**, when you have viewed the last image on a card it will go automatically to the other card.

Title Edit

You can add text titles or comments to one or more pictures. It works only with **JPG** files, not **RAW** or **JPG+RAW**. The title or comment can be viewed on the **Playback** screen by pressing the **DISP** button. If you have a suitable printer or print shop, this text can be stamped on the picture when it is printed. Pictures can be batch selected and titled if you select **Multi** from the dialog.

Face Rec Edit

If you have registered face recognition information on someone called 'Rocky' in **Face Recog** in the **Rec** menu and **Face Recog** is set to **On**, the camera may occasionally may apply this information wrongly. So, if you have registered a person called Rocky and when you view a picture of a young woman in a pretty dress, the G9 has applied his name and details to her, either the G9 knows something you do not or it has misapplied the recognition. This option allows you to clear the recognition data from this picture or change it.

RAW Processing

This allows you to process a **RAW** file to JPG in the camera. You can, of course, have the camera record **RAW** and JPG at the same time but this gives you individual processing capabilities over each **RAW** file. It covers the most important parameters that **RAW** editing software does on a computer but with a more limited range of adjustment. To use, scroll to the **RAW** image you wish to process and press **Set** in the bottom right of the monitor. Rotate the selector on the left of the monitor to the parameter you wish to change and press **Set** again. Adjust how you wish and press Set to finalize it. Go to the next parameter and repeat the process until you are satisfied with your picture. You can now scroll to the **Setup** (spanner icon) position which allows you to undo all your adjustments (**Reinstate Adjustments**) and start again. You can reset et **Color Space** and **Picture Size** too. When you are done, scroll to **Begin Processing** and hit **Set**. You are shown the original **RAW** and the JPG

version you have set up. You are asked if you want to go ahead, press **Yes** and the **JPG** is saved. Tap twice on the screen to magnify the image. When you see Disp. on screen, touch it and the original and processed images are shown together.

6K/4K PHOTO Bulk Saving

One of the problems with 6K/4K shooting is that it produces the still images in **MP4** movie form. You can play the **MP4** in camera and pick out frames you want to keep or transfer it to your computer and with suitable software such as **VLC Player**, run though and pick out the frames there. Both methods are fairly clunky. This menu item simplifies the task. Touch the menu item and find the **6K/4K** sequence you want to use. Having found it, press **Set** on the bottom right of the monitor. In the following dialog, press **Yes**. When the **Creating a Image** box has disappeared you will

see an image with this icon at the top left . This indicates that this image represents a group of images and while you don't see them on the camera, when you transfer the files to your computer you will see that the **MP4** file has been unbundled into its constituent still images. **6K/4K Photo Bulk Saving** will only work on files up to 5 seconds long. Remember that each second of **MP4** is 30 frames, so a 5 second sequence unbundled will give you 150 frames. 10 of them gives you 1,500 frames! Overall this is a very useful facility because it is so much easier to run through and choose frames on a computer

monitor where you can accurately judge sharpness and the best moment of action..

6K/4K PHOTO Noise Reduction

Applies noise reduction to high **ISO** burst photos automatically when saving them singly from the **MP4** file. It doesn't work on files that are bulk saved with the previous menu item.

Light Composition

You will have seen pictures of firework displays where the whole sky is ablaze with exploding fireworks. Yet you know from experience that no firework display sets off so many fireworks at once. One firework would mask another, the noises would conflict and the display would be over in a few minutes. On the other hand, in a still photograph, one lone firework going off on its own leaves a big black mass of empty sky. Underwhelming. Enter **Light Composition**. It does automatically what previously took skilled manipulation in an image editor. It combines single frames from a **6K/4K** burst sequence into one frame containing elements of all of them. Lets say a scene has a wall lit by flood-lamps and fireworks will be let off from behind that wall. You start your **6K/4K** burst and the 4th frame has a firework going off in the sky, another in the 12th, another in the 25th. The first frame will be used as a base image and shows just the wall. Frames 2 and 3 show the same scene and will be discarded since **Light Composition** only composites frames that have brighter parts than previous ones. Frame 4 has a firework going off so that area of the sky is brighter than the previous frame. Frames 12 and 25 are composited for the same reason.

We finish up with a picture that has the wall from the first frame and the fireworks from the 4, 12 and 25th frames combined into one picture. A longer sequence will contain more fireworks going off and thus more frames added, eventually giving a picture with fireworks filling the sky area. Plenty of other uses for this, night flights landing at airport, for example.

It is straightforward to use. Having shot your sequence, press **Light Composition** and choose the **6K/4K** sequence you want to use. Press **Set** on the bottom right of the screen. You see a dialog box **Composite Merging** or **Range Merging**. With **Composite Merging** you explicitly pick out the frames you want to use for your composition. You will see the usual video controls and a position slider at the top of the screen. Use any of these to find the first frame you want to use and press **OK**. Now press **Next** and move to the next frame you want to use. Press **OK**. If you accidentally set a frame, just press **Reselect**. Keep doing this until you have found all the frames you want to include in your composition. Then press **Save**. The G9 will combine the frames. If you select **Range Merging**, the procedure is the same but you are prompted to select where to start the range and where to finish the range. After you have selected the last image in the range, the G9 runs through all the frames in the range and combines them as appropriate. By its very nature the results of **Light Composition** are difficult to pre-visualise so I generally expect to make several tries using both methods and different frame selections before I am satisfied.

Clear Retouch

If have shot a perfect landscape but there is an electricity pylon ruining the sky, **Clear Retouch** is the tool to remove it. Choose your image and press **Set**. If you wish, enlarge the image using **Scaling** to give you a good view of the offending pylon. Press **Remove** and rub the screen with your finger or a stylus. You will see that a red mask appears where you rub. When you have masked out the pylon, press **Set** and after the camera has worked for a few seconds there is your landscape sans pylon. If you like it, press **Save**. If not press the arrow bottom left of the monitor and you can undo the changes and start again if you wish. While better done in post processing where you have a bigger monitor to work on, **Clear Retouch** nonetheless works very well. It does a similar job to Photoshop's **Spot Healing Brush**. This works only with files shot as **JPG**, not **RAW** or **RAW+jpg**. Handy for sending via **Wi-Fi**.

Text Stamp

You can add information to your picture(s).It works only with **JPG** files, not **RAW** or **JPG+RAW** You can set a **Shooting Date** (with or without time) add a **Name**, **Location**, set a travel date and add a **Title**. If you have a suitable printer or print shop, this text can be stamped on the picture when it is printed. You can only add a **Name** previously registered to **Face Recog.** - you will see it listed.

Copy

You can copy pictures from one card to the other. Handy for backup or where you have designated one

card for **RAW** and the other for **JPG**, say. If the **RAW** card fills up, you could copy the to the other card and then empty the origin card.

Copy Direction

Select which way the copy is to run.

Select Copy

You can copy up to 100 images at a time from either card to the other. Select the relevant folder and then the files you want to copy. Conformation of the destination appears with a Yes/No option to continue.

Copy All In Folder

As **Select Copy** but having selected the folder, all files in it will be transferred without needing individual selection.

Copy All in Card

All files will be copied to the other card in the direction specified in **Copy Direction**. **Note:** you cannot copy **Protect**ed files.

Resize

This works only with files shot as **JPG**, not **RAW** or **RAW+JPG** or **6K/4K**. If you have shot a picture or pictures at, say **Large**, press this and you can reduce it to **Medium** or **Small**. You can either save it as a new picture in which case a copy is made and you have both the large and small files or, by answering **No** to the 'Save as a new picture?' dialog, overwrite it and retain only the small version. Handy for sending via **Wi-Fi**.

Cropping

Bring up the picture you want to **Crop** and press **Menu/Set**. Using the rear dial and cursor keys get the

image framing that you want. Press **Menu/Set** again and you can choose to keep both the cropped and uncropped original or overwrite the original. **Note:** you can't crop **RAW** files.

Rotate

rotate your image manually. Normally the camera will take care of the image orientation but occasionally it gets it wrong.

Video Divide

This splits a video into two parts. It is not undo-able in camera. Handy for rudimentary editing. In **Playback** mode, you select the video you want to divide and the video plays back overlaid with the normal forward/ back/pause controls. Stop it where you want to split it and press the little scissors icon.

Time Lapse Video

After shooting with **Time Lapse Shot** (**Rec** Menu), you can assemble your frames into an **mp4** video here. Set the parameters below and press **OK.**

Stop Motion Video

As **Time Lapse Video**

Rotate Disp.

With this **Off**, a picture shot in portrait orientation when reviewed on the monitor will be played back in portrait orientation, meaning you must turn the camera to see it properly. With this **On**, the portrait orientated pictures are displayed rotated to landscape orientation. It is more convenient but means the image will have a black band either side and occupy only a portion of the monitor.

Picture Sort

Plays back images in the order they were taken or by filename. A lot of the time this will amount to the same thing, of course.

Delete Confirmation

When you want to delete a picture from the SD card, you are always asked to confirm the deletion. This sets the default to **Yes** or **No**, saving you a key press.

iA Menu

iA has two modes, **iA** and **iA+**. Essentially, these two modes turn the G9 into a rather large point and shoot camera. If that sounds rather demeaning, the fact is that every photographer is asked at some time to bring his camera along to some family or friends event. These intelligent modes are ideal for such tasks and for holidays too, where you might want to relax and just take a few snaps as mementoes. The menus for both identical to the normal menus but a sub-set of them, with more options available for **iA+**. Whichever you choose, that is the one that will be invoked when you turn the **Mode Dial** to **iA**. The menu settings that the camera will take care of are greyed out with the others being available for your selection. If you fit a Micro Four Thirds system flash, operation will be taken care of without your intervention. The annoying part of **Intelligent Auto** is just how effective it is!

iA

The camera will automatically detect and set itself for the scene mode, face recognition and so on. You can choose whether it will autocratically shoot and process the bursts necessary for **iHandheld Night Shot** and **iHDR**.

iA+

iHandheld Night Shot and **iHDR** will be invoked if the camera deems it necessary. There are rather more menu options available. **Note:** If you press **Fn4** the Defocus control appears. This lets you set the lens aperture and shows you its live effect on depth of field. Press the **WB** button and turning the rear dial will alter

the image colours. Press the **Exposure Compensation** button and the rear dial will change image brightness.

My Example Menu

Note:

1. The permanent menu headings are **Rec**, **Motion Picture**, **Custom**, **Setup**, **My Menu** and **Playback** but others are added at the top of that list when particular shooting modes are selected (see item 2)

2. When the **Mode Dial** is set to **iA**, **Creative Video**, **C1-2-3** or **Creative Control** a menu devoted to the extra facilities which that setting offers appears at the top of the menu list. The main one is **Creative Video** which I have placed here after the **Motion Picture** menu since they are so closely related. I also list **iA** but the others simply duplicate entries already covered

3. You can access the **Motion Picture** menu while in a stills mode such **A** or **M** or with the **Mode Dial** set to **Creative Video**. The settings made while in a stills mode set what type of video will be shot when the **Motion Picture** red button is pressed while in a stills mode. When set to **Creative Video** you can access a few extra settings in the **Creative Video** menu

The following listing is my all purpose menu. I like to shoot **RAW** plus **JPG** for maximum flexibility. If you prefer **JPG** only, you might like to set **Double Slot**

Function to **Relay Rec** to make best use of the twin cards.

Rec Menu

- **Aspect Ratio** - 4:3
- **Picture Size** - L 20M
- **AFS/AFF** - AFS
- **AF Custom Setting(Photo)** - Set 1
- **Photo Style** - STD
- **Filter Settings** - OFF
- **Filter Select** - OFF (Sim Rec. ON if used)
- **Color Space** - sRGB
- **Metering Mode** - Multiple
- **Highlight Shadow** - OFF
- **i.Dynamic** - OFF
- **i.Resolution** - OFF
- **Flash** - As Applicable but TTL normally
- **Red-Eye Removal** - OFF
- **ISO Sensitivity (photo)** - 200 Lower/ 3200 Upper
- **Min Shtr Speed** - 1/125th
- **Long Shtr NR** - ON
- **Shading Comp** - OFF

- **Diffraction Compensation** - OFF
- **Stabilizer** - ON normal
- **Ex.Tele Conv.** - OFF
- **Digital Zoom** - OFF
- **Burst Shot 1 & 2 Setting** - M 7fps/SH1 PRE
- **6K/4K Photo** - 6K PRE
- **Post Focus** - 6K
- **Self Timer** - 10
- **High Resolution Mode** - OFF (80Mp when used)
- **Time Lapse Animation** - As Applicable
- **Silent Mode** - OFF
- **Shutter Type** - MSHTR
- **Shutter Delay** - OFF (2 sec when used to steady camera)
- **Bracket** - OFF (Exposure/ 3 shots/ one stop either side of normal when used)
- **HDR** - OFF (Auto when used)
- **Multi Exp** - As Applicable
- **Time Stamp Rec** - OFF

Motion Picture Menu

- **Rec Format** - MP4

- **Rec Quality** - 4k 100M 25p (30p in NTSC areas) - 4k because of editing potential
- **AFS/AFF** - AFS
- **Continuous AF** - ON
- **Photo Style** - STD
- **Filter Settings** - OFF
- **Luminance Level** - 16-255
- **Metering Mode** - Multiple
- **Highlight Shadow** - OFF
- **i.Dynamic** - OFF
- **i.Resolution** - OFF
- **ISO Sensitivity (video)** - 200 Lower/ 3200 Upper
- **Shading Comp** - OFF
- **Diffraction Compensation** - Auto
- **Stabilizer** - Normal/ E-Stab OFF/ I.S. Lock when applicable
- **Flkr Decrease** - OFF
- **Ex. Tele Conv.** - OFF
- **Digital Zoom** - OFF
- **Picture Mode in Rec.** - Video Priority
- **Time Stamp Rec** - OFF
- **Mic Level Disp.** - ON
- **Mic Level Adj.** - As Applicable
- **Mic Level Limiter** - ON

- **Wind Noise Canceller** - OFF (Usually Standard, if necessary)
- **Lens Noise Cut** - OFF
- **Special Mic** - As Applicable
- **Sound Output** - Rec Sound

Creative Video Menu

- **Exposure Mode** - M ideally, if not A
- **High Speed Video** - OFF
- **Variable Frame Rate** - OFF
- **HLG View Assist** - OFF
- **4K Live Cropping** - OFF

Custom Menu - Exposure

- **ISO Increments** - 1EV
- **Extended ISO** - OFF
- **Exposure Offset Adjust.** - OFF
- **Exposure Comp. Reset** - ON

Custom Menu - Focus/ Release Shutter

- **AF/AE Lock** - AF Lock
- **AF/AE Lock Hold** - ON
- **Shutter AF** - ON
- **Half Press Release** - OFF

- **Quick AF** - OFF

- **Eye Sensor AF** - ON

- **Pinpoint AF Setting** - MID/ PIP

- **AF-Point Scope Setting** - ON/ PIP

- **AF Assist Lamp** - OFF

- **Focus/Release Priority** - FOCUS/BALANCE

- **Focus Switching for Vert/Hor** - OFF

- **Loop Movement Focus Frame** - ON

- **AF Area Display** - ON

- **AF+MF** - OFF

- **MF Assist** - FOCUS (2nd from top)

- **MF Assist Display** - PIP

Custom Menu - Operation

- **Fn Button Set** - As Applicable (see my suggestions in book text)

- **Fn Lever Setting** - 1. MSHTR 2.ESHTR

- **WB/ISO/Expo. Button** - AFTER PRESSING

- **Q.Menu** - As Applicable (see my suggestion in book text)

- **Dial Set.** - As Applicable but Exposure Comp set to front dial

- **Joystick Setting** - D.Focus

- **Operation Lock Setting -** OFF/OFF/ON/OFF

- **Focus Ring Lock** - OFF

- **Video Button** - ON

- **Touch settings** - ON/OFF/AF/OFF

- **Auto Review** - ALL OFF/ 3 SEC if used.

- **Monochrome Live View** - OFF

- **Constant Preview** - ON

- **Live View Boost** - OFF

- **Peaking** - ON/HIGH/BLUE

- **Histogram** - OFF

- **Guide Line** - OFF

- **Center Marker** - OFF

- **Highlight** - OFF

- **Zebra Pattern** - OFF

- **Expo.Meter** - OFF

- **MF Guide** - ON

- **LVF/Monitor Disp. Set -** OUTSIDE/INSIDE

- **Monitor Info. Display** - ON

- **Rec Area** - Stills

- **Remaining Disp.** - Stills

- **Menu Guide** - OFF

Custom Menu - Lens / Others

- **Lens Position Resume** - OFF
- **Power Zoom Lens** - As Applicable
- **Lens Fn Button Setting** - FOCUS STOP
- **Face Recog.** - OFF
- **Profile Setup** - OFF

Setup Menu

- **Online Manual** - N/A
- **Cust.Set Mem.** - N/A
- **Clock Set** - N/A
- **Style** - N/A
- **World Time** - N/A
- **Destination** - N/A
- **Home** - N/A
- **Travel Date** - N/A
- **Travel Setup** - N/A
- **Location** - N/A
- **Wi-Fi** - N/A
- **Wi-Fi Function** - N/A
- **Bluetooth** - N/A
- **Wireless Connection Lamp** - ON
- **Beep** - Medium/Medium/2
- **Headphone Volume** - As Applicable

- **Economy** - 2MIN/ON/2MIN/Power Save 5SEC/LIVE VIEW

- **Monitor Speed Display** - 60fps

- **LVF Display Speed** - 120fps

- **Night Mode** - OFF

- **Monitor Display** - ALL Centre

- **Monitor Luminance** - A*

- **Status-LCD Backlight** - H

- **Eye Sensor** - LOW/AUTO

- **Battery Use Priority** - BG (If fitted)

- **USB Mode** - Storage

- **USB Power Supply** - ON

- **TV Connection** - As Applicable

- **Language** -As Applicable

- **Version Disp.** - N/A

- **Folder/File Settings** - All as default but name setting PG9_

- **Activate** - N/A

- **Double Slot Function** - Allocation REC/2/1/2/2

- **No.Reset** - N/A

- **Reset** - N/A

- **Reset Network Settings** - N/A

- **Pixel Refresh** - N/A

- **Reset Network Settings** - N/A

- **Pixel Refresh** - N/A
- **Sensor Cleaning** - N/A
- **Level Gauge Adjust** - N/A
- **Format** - N/A

Playback Menu

- **Slide Show** - N/A
- **Effect** - N/A
- **Setup** - N/A
- **Sound** - N/A
- **Playback Mode** - N/A
- **Protect** - N/A
- **Multi** - N/A
- **Cancel** - N/A
- **Rating** - N/A
- **Title Edit** - N/A
- **Face Rec Edit** - N/A
- **RAW Processing** - N/A
- **6K/4K PHOTO Bulk Saving** - N/A
- **6K/4K PHOTO Noise Reduction** - N/A
- **Light Composition** - N/A
- **Clear Retouch** - N/A
- **Text Stamp** - N/A
- **Copy** - N/A

- **Copy Direction** - N/A
- **Select Copy** - N/A
- **Copy All In Folder** - N/A
- **Copy All in Card** - N/A
- **Resize** - N/A
- **Cropping** - N/A
- **Rotate** - N/A
- **Video Divide** - N/A
- **Time Lapse Video** - N/A
- **Stop Motion Video** - N/A
- **Rotate Disp.** - ON
- **Picture Sort** - DATE/TIME
- **Delete Confirmation** - YES first
- **iA Menu** -
- **iA** -
- **iA+** -

Focus Stacking Example

This is a frame from the **Focus Stack**, shot at f/5.6. You can see that There is nowhere near enough depth of field to get the whole row of batteries into focus. Of course, there would be more depth of field if I had stopped down to f/16 or f/22 but with a Micro Four Thirds lens sharpness suffers dramatically at those small apertures, due to diffraction. This image was shot on an Olympus 12-

40mm f/2.8 zoom at 40mm. With such a lens, the
optimum sharpness is at f/4 to f/5.6.

This image is the result of **Post
Focus → Auto Stacking**. As you can see the G9 has
made a superb job of rendering the line of machine
heads sharp with little sign that the image is a
combination of many frames.

Multi Exposure Example

 A Multi. Exp used to compare
the size of two Micro Four Thirds cameras. The
technique is easy with Auto Gain switched On. Just
put one camera down,make an exposure. Then put the
second one down, expose that and press Exit. The g9
does the rest.

<u>High Resolution Example</u>

 Here's a **High Resolution** 80Mp image. It doesn't look any different from a normal resolution image when viewed on a page like this. However, the 80Mp image has hidden reserves of detail contained in the file - see the image below.

178

of the image above. Such a crop taken from a normal resolution image would tend to be lacking in detail and look like the crop that it is. Here, though, taken from the 80Mp original,the crop looks no less sharp than the original. In fact, I could crop further, just one of the windows and the quality would not deteriorate significantly. The corollary to this is that you could, if you wished, make a critically sharp print of between 3 and four feet across from this image. In practise, because the viewing size would be greater, you could use such a shot for a 6ft poster, normally the province of a medium format camera. The downside is that the subject must be stationary for the five several seconds that the G9 needs to make such a picture. Not to forget that not all lenses will are able to render the level of detail necessary to make the best of 80Mp.

High Dynamic Range Example

general because they are so often overdone and look processed and unnatural. Sometimes, though, HDR can achieve something that would be hard or impossible to do any other way. This interior shot above is fine but it is obvious that more colour and tones in the image would liven it up visually. You could achieve some improvement in Photoshop but the G9's HDR routine does it the painless way and in Auto

gets a very fine and pictorial result - see below.

184

Rolling Shutter or Jello effect Example

The rolling shutter or jello effect of the electronic shutter on all mirrorless cameras. It happens because the sensor is read progressively from top to bottom and, fast as this is, in the fraction of a second it takes to read, the subject will have moved. If you look at the vertical body line on this van, the top is

where the van was when the shutter was pressed and the bottom where is was when it finished. In day to day subjects the effect is unnoticeable but with a fast moving vehicle moving across the field of view like this, it is shown at its worst.

www.ingramcontent.com/pod-product-compliance
Lightning Source LLC
Chambersburg PA
CBHW052315220526
45472CB00001B/126